Wicked
Bay City
MICHIGAN

Wicked Bay City
MICHIGAN

Tim Younkman

Published by The History Press
Charleston, SC
www.historypress.net

Copyright © 2016 by Tim Younkman
All rights reserved

First published 2016

Manufactured in the United States

ISBN 978.1.46713.554.2

Library of Congress Control Number: 2015958230

Notice: The information in this book is true and complete to the best of our knowledge. It is offered without guarantee on the part of the author or The History Press. The author and The History Press disclaim all liability in connection with the use of this book.

All rights reserved. No part of this book may be reproduced or transmitted in any form whatsoever without prior written permission from the publisher except in the case of brief quotations embodied in critical articles and reviews.

Contents

Acknowledgements 7
Introduction 9

1. Hell's Half Mile 11
2. The Polish War 28
3. AWOL for Murder 52
4. Young Boy's Death Changed the Law 58
5. Death of a Lumber Baron 62
6. Rise and Fall of the South End Gang 72
7. The Case of the Murdering Mogul 91
8. Ten Hours or No Sawdust 103
9. Canada Jack's Twelfth Street Gang 112

Bibliography 123
About the Author 125

Acknowledgements

I extend my sincere appreciation to Ron Bloomfield, director of the Bay County Historical Museum for the contribution of time and help gathering the array of photographs for this project. I also extend thanks to Chris Applin of the Public Libraries of Saginaw for locating interesting photographs of lumbering-era sawmills in Saginaw that were involved in the 1885 major lumber strike along the Saginaw River.

Introduction

Carved from the virgin pine forests lining the Saginaw River, the community later known as Bay City was little more than a fur trader's outpost in the northern frontier. Its first settlers dealt with the French Canadian trappers and Native American tribesmen who traversed the land and waterways in the 1830s and 1840s.

For its first quarter century, the community grew to about 1,500 souls, but after the Civil War, the population soared. The 1870 census showed more than 7,000 people in Bay City. For all that time, crime and scandals had been managed by a rudimentary law enforcement and court system, effective enough to handle the problems that arose.

However, as evidenced by the growing population, something else was afoot—King Lumber. The demand for lumber and wood products was rising at a colossal rate, and Bay City was ideally situated to provide hundreds of millions of board feet a year to the hungry sawmills, which were growing in size and number.

Being on a river feeding into the Saginaw Bay and Lake Huron beyond, Bay City bustled with the water transport of lumber and wood products to all ports on the Great Lakes. When the railroad arrived in 1869, the movement of lumber by land greatly increased the business, further adding to a millionaire upper class of lumber barons.

In order for these well-to-do businessmen to get rich and stay wealthy, thousands of workers were needed to toil in the lumber camps and in the one hundred sawmills that lined both sides of the river from its mouth all

Introduction

the way south to Saginaw City. Many of the workers were newly arrived immigrants who first landed in teeming, crowded New York and immediately moved west when they heard work was available. A large number of them settled in Bay City, some with their entire families.

It should be noted that Bay City was a community only on the east side of the river; on the opposite side was a separate city known as West Bay City, having formed in 1877 from the merging of three villages: Banks, Salzburg and Wenona. When West Bay City merged with Bay City in 1905, the West Side contained about fifteen thousand residents.

The tales of dark hearts in Wicked Bay City involve the wild events occurring during the rise, the reign and the fall of King Lumber.

Chapter 1
HELL'S HALF MILE

Bay City could have been called Sin City.
Men with pay in their pockets, bent on guzzling liquor, waging bets in makeshift casinos and romancing a few "ladies of the town," could find it all in the red-light district known not affectionately as Hell's Half Mile. It stretched north and south on the east side riverfront for twelve blocks and was three blocks deep (more counting a few east–west streets).

Lumber was king from the Civil War to the turn of the twentieth century, a sustained economic expansion that created millionaires who built mansions in Bay City and invested in other industries, making their fortunes from the thousands of laborers working long hours for minimum pay.

Between five and ten thousand men worked in the lumber camps throughout central and northern Michigan, and many saved most or all of their pay during the winter "felling" season. In the spring, when the long winter's ice on the Saginaw River and Saginaw Bay broke up, local citizens knew it was time to steer clear of the waterfront because the invasion of the woodsmen was coming, a virtual month-long Mardi Gras for axe men and windfall for legitimate merchants and illegal sporting houses alike.

These rugged backwoods lumberjacks roared into Bay City because it was the nearest town with enough dens of iniquity to satisfy every peccadillo and addiction, and if gambling, liquor, sex and bawdy dance hall entertainment wasn't enough, a few of them also were entertained by beating unlucky locals they'd encounter, sometimes robbing them. Or they would attack one another, using fists, knives and even teeth.

Wicked Bay City, Michigan

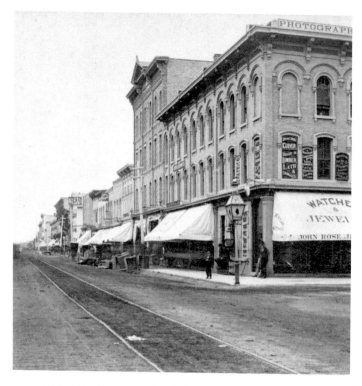

The heart of Hell's Half Mile stretched north in this view of Water Street near Center Avenue. Thousands of lumberjacks descended on the red-light district each spring. *Bay County Historical Museum.*

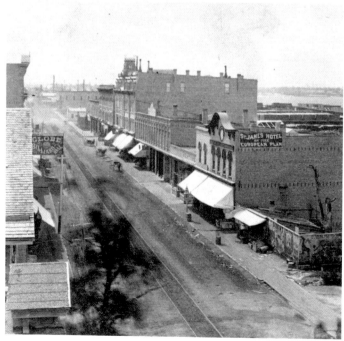

Water Street looking south from Fifth Street appears to be a normal business district, but the top floors and underground are where much of the action could be found. *Bay County Historical Museum.*

Timber fellers gather around for a meal after a long day's work in the northern lumber camp, no doubt thinking about spending their pay on Hell's Half Mile at winter's end. *Bay County Historical Museum.*

However, only a few used guns to settle arguments because that would be the act of an unmanly coward.

As early as May 1865, attempts were made to at least restrict the wide-open aspect of the red-light district. These included making it illegal to sell alcoholic beverages to youths under fifteen and outlawing "houses of ill fame." The saloons also were supposed to be closed all day on Sunday, and they had to be licensed by the city. At least the laws were on the books even if enforcement was lax.

While low-level violence was common enough, with maiming and scarring the intent, murders were rare. An incident from 1891 provides an example of the typical crimes for the area. The bar proprietor of the Anscomb House hotel, on the northeast corner of Third and Washington Streets, was arrested for attempting to bite off the nose of a customer who had become unruly. They had tangled in an argument, and as they fought, the barman chomped down on the other man's beak, causing extensive bleeding and requiring minor surgery. Most cases ended in the accused paying a fine.

The entertainment in Hell's Half Mile didn't end when the invaders' money ran out because the spring thaw triggered the start-up of nearly one hundred sawmills on the Saginaw River from its mouth at Saginaw Bay all the way up to Saginaw City. The mills employed many of the

lumberjacks, along with thousands of newly arriving German, Polish and Irish immigrants.

To the good, God-fearing townsfolk, the waterfront really was the Devil's Playground, aimed at satisfying any and all of the hardy men emerging from their winter-long occupation of cutting down the vast pine and hardwood forests and relieving them of their hard-earned wages. Local businessmen simply called it "Water Street," meaning the entire red-light district, and when spring arrived, their eyes would light up in anticipation of raking in tons of money that flowed from the pockets of the wildly enthusiastic "timber fellers."

Throughout the year, but most certainly from Easter to Pentecost, the local preachers railed against anyone partaking of the Water Street specials and even tried for many years to organize protests. Local historian Leslie Arndt, who penned several books on the development of the city from its sawdust days to the modern era, noted that the local branch of the Anti-Saloon League, known as the Red Ribbon Brigade, tried to get the city fathers to shut down the businesses and wipe out the caves of corruption without a great deal of success. There were several instances of the police being given the go-ahead to make a few arrests to placate the boisterous protestors, but for the most part Hell's Half Mile was allowed to operate with the loosest of tethers.

While there were a few bars and hotels on the other side of the river in West Bay City, it was Bay City's red-light district that attracted most of the business. It was fired to life in earnest as the Civil War ended, when entrepreneurs, some flush with their heavy war-profiteering moneybags, began buying up huge tracts of the forested lands that covered most of the state of Michigan. Bay City went from a sleepy little village to a bustling, loud, dusty boom town as those same money men not only set up dozens of large lumber camps but also built huge sawmills all along the Saginaw River. The city was situated perfectly upriver far enough from the swirling Saginaw Bay waters to provide a safe haven from the weather.

Arndt points out that the numerous lumber mills were the destination of gigantic booms of logs pulled by tugs to be distributed to the proper mills, much like a Wild West cattle roundup. A boom was a ring of logs attached with spikes and chains that corralled hundreds of other logs that then could be towed intact from the Saginaw Bay up the river. The lumberjacks used a hammer with a design on the tip that was pounded into the log end, branding it to identify the mill where the log was destined.

The parallel streets closest to the waterfront, Water and Saginaw Streets and even parts of Washington Avenue, featured much of the wild

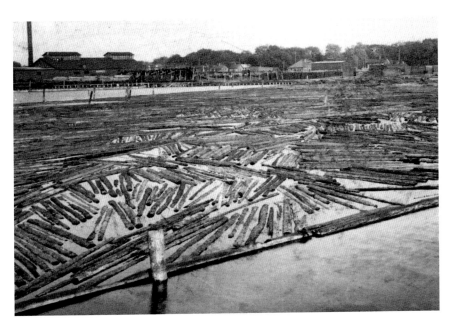

Thousands of huge logs were towed by tugboats each year inside floating corrals called booms like this one to the one hundred Saginaw River sawmills. *Bay County Historical Museum.*

entertainment aimed at the money-laden lumber boys when as many as five thousand of them descended on the wooden sidewalks in their caulked boots. Most of the men hadn't spent much, if any, of their pay from the winter months of hard labor and were eager to do so as soon as they leapt from the trains in the Bay City stations.

While the youngest of the men headed for the saloons at once, the smarter, more seasoned lumberjacks made sure to get to the barbershops for shaves, haircuts and baths before going, most likely, to one of the local tailors to order some new clothes. They then would make sure to get a nice room in one of the better hotels, real ones and not the so-called hotels that doubled as bordellos. Generally, they would pay in advance for a few nights to guarantee they'd have nice accommodations at least in the short term.

These veteran lumber boys knew that with the proper appearance, they'd be able to get their choice of "more refined" ladies in some of the better sporting houses. Of course, besides the lumberjacks, there were thousands of other laborers from other industries also on the prowl looking for a good time.

To the visitor arriving either by train at one of the downtown stations or by passenger boat, the Water Street district appeared to be a normal business quarter because the entire district was saturated

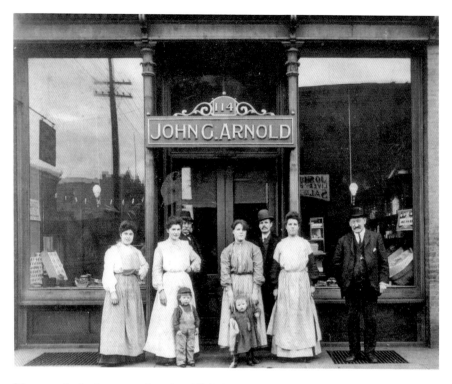

Many regular businesses, such as Arnold's Bakery, operated in the Hell's Half Mile area. The bakery was located for years at 114 Center Avenue before relocating around the corner on Saginaw Avenue. *Bay County Historical Museum.*

with legitimate businesses, at least on the ground floors of the two- or three-story buildings.

At the height of the lumber boom, an 1887 city directory noted there were twenty-two saloons and eight hotels on North Water Street alone. More of them were to be found on Saginaw Street and even the main thoroughfare of Washington Avenue.

In total, the entire red-light district featured fifty-two saloons and thirty-five hotels, with many if not most of them of the unsavory variety. There even were eighteen physicians who headquartered in the district since that's where they were needed most. It also was home to Bay City's city hall and police station, situated in the center of the action on Saginaw Street, between Center and Fifth.

The saloons, restaurants and hotels were constantly monitored by the city's health officer, who doubled as a truant officer. These establishments had to be licensed by the city, receive a favorable report and display a placard

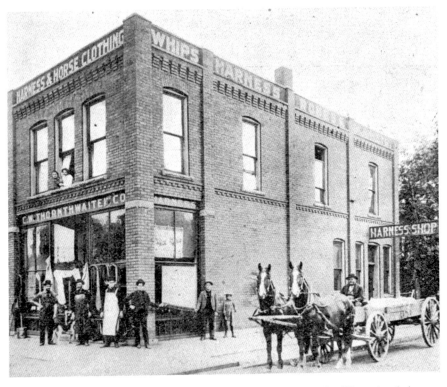

Essential businesses related to the horse-and-carriage trade—including Thornthwaite's harness shop, shown here at 200 Sixth Street—were located in the waterfront district. *Bay County Historical Museum.*

of approval from the officer. While the places listed in the directory were legitimate businesses, they nonetheless catered to all vices on their property.

One of those saloons was called, unabashedly, the Red Light Saloon and was identified by police and local citizens as the vilest of establishments. Located at 109 Fourth Street between Water and Saginaw, it featured an entrance on the street and another more secretive and unmarked one from the alley alongside it. It had several stories of lewd and degrading performances in the large room and a number of stalls where the women worked their wiles. It finally was abandoned in 1895 after more than twenty-five years in business despite occasional raids by police.

Another sporting house of infamous notoriety was the Social Saloon, possibly part of the Montreal House, which posed as a hotel on the corner of Water and Seventh Streets. Police listed it in the class of the Red Light Saloon. It was also closed in 1895 by a mysterious fire.

One area of Hell's Half Mile still talked about today was the Catacombs. Originally, the name was generic, as many of the basement bordellos and gambling rooms were connected through underground passages. The epicenter of the Catacombs was Third and Water Streets near the busy Third Street Bridge, which connected the Bay City and West Bay City. Later on, one of the large buildings on the corner actually called itself the Catacombs, though not officially.

In fact, a news item of May 11, 1889, discussed some of the more disgusting aspects of that area. Health officer Andrew Wyman reported vile conditions in the underground tunnels near the Third Street Bridge, pointing out a large room called the "five-cent room," where lumberjacks with a nickel or two left might rent a cot for a night. But it was five cents for a reason: the stench was unbearable. He said the room next to it was filled with vegetable parings and meat cuttings that the restaurants above had discarded throughout the winter; this detritus had been frozen but had begun to rot in the heat of late spring. Wyman served health ordinance violations against the businesses aboveground, ordering a cleanup.

The Catacombs sporting house, Arndt notes in his book, was said to feature a trapdoor through which unruly troublemakers or even robbery victims were dropped down into the river. That was a myth, Arndt points out, since the river never came that close to the building. However, a trapdoor would have been handy simply to get rid of combative or liquor-filled comatose customers, dropping them down onto the sawdust-covered ground below.

The waterfront saloons weren't necessarily large concerns, with most of the gambling action and female companionship available in backrooms and on the upper floors. Several of the second-floor halls featured forms of burlesque or dance hall shows. None of it was legal, but it was tolerated by the city's authorities for several reasons—namely, money and safety.

None of the local population wanted these roughnecks wandering the residential neighborhoods looking for fun and entertainment, so keeping it confined to the waterfront was the lesser of evils. It wasn't as if the police totally disregarded law violators; they made efforts to control the situation. A report to the city police commission in August 1882 noted officers had arrested fifteen prostitutes, sixty people for being drunk in public and one saloonist for doing business on Sundays that month.

The idea that money was to be made was an understatement. Many of the men earned $150 or so during the winter, and they might bring some or all it with them. If the lumberjacks and other visitors carried an average of $100, that's a cool $500,000 for local vendors, legitimate or otherwise. It

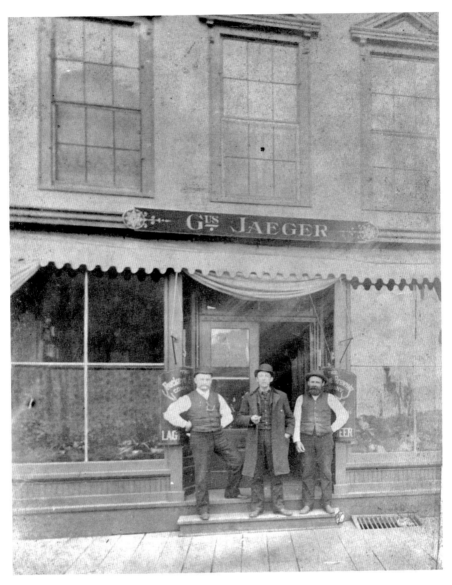

There were fifty-two saloons in Hell's Half Mile, including Gus Jaeger's place at 600 North Water Street on the northeast corner of Seventh Street. *Bay County Historical Museum.*

was common knowledge that many of the hard-drinking lumber boys were going to spend just about every dime while in town.

The waterfront featured classic brawls among drunken lumberjacks, coal miners, merchant sailors, railroad men, shipyard hands, dock workers,

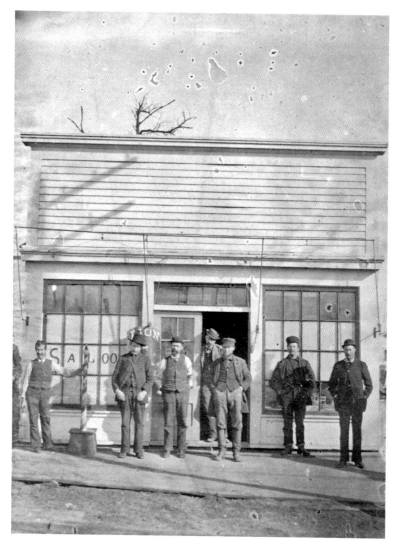

This saloon/barbershop/cigar stand, called the Lion, hugged the waterfront like scores of other businesses catering to the thousands of lumberjacks and industrial workers. *Bay County Historical Museum.*

construction crews and any combination of them. With only about twenty police officers, Bay City's first police chief, Nathaniel Murphy, had his hands full.

He was a tall, rugged, no-nonsense man who led by example and hired the biggest, toughest men, many former lumberjacks, who could take orders and take care of themselves in a fight. The idea of training policemen in the

law was rudimentary at best, but Murphy insisted on at least some training for his officers, not necessarily to avoid lawsuits but to keep them alert and safe when handling tough situations.

With so few men on the police force, intervening in the midst of thousands of revelers was a significant challenge. Common sense and tact were favored with brute force being a last resort.

An example of problems police faced, not to mention the combatants, occurred among some shanty boys on their first day in town on April 1, 1890. A group of the lumber boys had gathered in a saloon near Saginaw Street and Center Avenue when an argument ensued, leading a group of them to face off outside. One of the tough lumberjacks, named Jack O'Brien, engaged in a pushing match with shanty boy John P. White. The two men clinched, and O'Brien knocked his adversary down and jumped on him. As the two skirmished, O'Brien clamped his teeth onto the other man's lower lip and chewed off a portion of it, spitting it to the ground. At that moment, policeman Samuel M. Catlin arrived on the scene, and O'Brien jumped up, blood covering his face, and spat at Catlin's feet while another lumberjack, named McFadden, launched himself at the policeman, striking him in the face.

Catlin grabbed the attacker, twirled him around and clamped him in a choke hold, wrestling him to the ground. Observers said it was at that point that the fight drained from McFadden. More patrolmen ran up from the station a block away, latched on to McFadden and scooped up a very bloody White. They got the two troublemakers to the station before getting a doctor for White and were able to sort out what had happened. McFadden was fined forty dollars, and O'Brien was sent to the Detroit House of Corrections.

One of the more notable characters, though some thought him to be vicious, was lumberjack Fabian Fournier, a figure researched by local historian and author D. Laurence Rogers. In his book *Paul Bunyan: How a Terrible Timber Feller Became a Legend*, Rogers describes how Fournier's life was a template for the tales of Paul Bunyan. Among other attributes, Rogers notes, Fournier had two sets of teeth and would win money in saloons from men who bet against him that he couldn't take a bite out of the wooden bar, which he did with great gusto.

Fournier also was a brawler who reveled in taking on other ornery lumberjacks, and one of his fights led to his undoing. He had tussled with a man during a riverboat excursion on Saginaw Bay on November 7, 1875, and as he walked down the gang plank at the Bay City dock, the man known as "Blinky" Robertson struck him from behind with a wooden ship mallet.

Many of those convicted of felonies in the early days were sent to the Detroit House of Corrections, shown here, a state-run prison institution. *Library of Congress.*

The blow struck Fournier above the left ear and killed him instantly, and Robertson disappeared into the night.

Sometimes, those engaged in crimes were local thugs who didn't work at all but got money by extortion and robbery. One of them was Thomas Preston, a man well known to police who was constantly being picked up for one crime or another. On January 11, 1881, another of his victims, a bleeding and beaten Daniel O'Hearn stumbled into the police station to file a complaint against Preston, claiming they'd been drinking in a saloon at Fourth and Water Streets when Preston suddenly attacked him.

He said Preston knocked him down and beat him, ripping his vest pocket to remove about nineteen dollars in cash. When police found Preston in the saloon spending money on drinks, he was detained and taken to the police station, where the money was found in his pocket and officers noted Preston's hands were bleeding. He also was found guilty and sent to the Detroit House of Corrections.

Fights and battles on the streets were handled year-round by the police, although there were more of them and with greater numbers

of combatants when the shanty boys arrived in the spring. Even in the winter, there was always some traffic from the lumber camps, as men would come in by rail with their monthly pay to stay for a day or two. Many sawmills also did some work throughout the year, and workers often spent their hard-earned pay in the brothels and bars of Hell's Half Mile. Hundreds of men who worked in the shipyards, sailors who stayed the winter in town, farmworkers with little to do in cold weather and men from the growing number of manufacturing plants spent money on Water Street. The mixture of men, liquor, cash and hookers was a recipe for violence.

One such celebrated case involved Jabez Knight, a lumberman who had been working at a mill in Au Gres on the north side of Saginaw Bay. He ventured into Bay City during Christmas week 1884 and enjoyed spending time with a "lady of the town" named Lou Hall in an establishment called the "Block of Blazes."

Actually, it was a T-shaped building on Second and Jefferson Streets along one of the eastern tentacles of Hell's Half Mile, five blocks from the river. The cross section was a one-story saloon, with an attached long two-story section providing rooms for gambling and sex.

What happened to the unfortunate thirty-five-year-old woman became a big story in the local papers with lots of interest and provided an opportunity for police chief Murphy to instruct some of his officers on how to secure evidence and question suspects and witnesses.

Lou Hall, sometimes known as Lou Stratton and Lou Slade, grew up on a farm in Columbiaville, Michigan, but was a restless soul who decided to find some excitement on her own. She ran away from home as a teenager, finding her way to East Saginaw, and ended up working in a brothel there. She began to bounce around from one house to another.

She had married John Hall but left him, and after a series of marriages sans divorces, she became the companion of a man named Frank Hall, no relation to the first Mr. Hall. He was arrested on charges of forgery, and she was accused of being an accessory. She agreed to come to Bay City to testify against him and then was released while Hall was sentenced to ten years in prison. At her age, Lou Hall's lifestyle had taken its toll on her features, but she still found that men were interested in her—so long as the lights were dim and the liquor was flowing.

The bar's proprietor, George Gignac, and the madam, Sarah J. "Jennie" Dubay, also had rooms in the building, most likely on the second floor, while the entire building was owned by John Giroux.

The hard-drinking sawyer, Knight, forty-five, had come to town with money in his pocket and a desire to spend it on liquor and Lou Hall. While he did give her some money, he didn't occupy all of her time, and she entertained a number of men during that week, all the way through New Year's Day. Still, when Lou was ready to go to sleep, Jabez would join her in her small bedroom on the first floor off the barroom.

On the night of January 2, 1885, he drank quite a bit and went to bed in her room. At some point, he got up and went into the nearby kitchen and talked to the madam, asking for a flatiron to be heated because it was so cold in the bed and he needed it to warm his feet. It was common to place a warm iron at the end of the bed to provide warmth on bitterly cold nights. Newspapers reported what happened next.

It wasn't clear when Lou Hall came to bed. However, Jabez Knight awoke at about daybreak. A boy working for the owner, stoking the fire in the stoves and cleaning the floors, was startled when he heard a man walk up behind him. According to news accounts, he was even more aghast when he turned and saw him.

Knight was covered in blood. He asked the boy for a drink of water and went to a bucket, scooping several drinks before he told the boy: "You had better go in there and see a terrible sight."

The young man cautiously went into the room and saw Lou Hall soaked in blood and moaning. Her face and skull had been mutilated, and there were obvious slash marks.

The boy ran back out and woke up Jennie Dubay, who then confronted Knight.

"You murdered Lou Hall!" she exclaimed.

"Well, you'll have to convict me before you can punish me," Knight muttered.

She sent the lad to fetch the doctor.

In those days, there was nothing like ambulances, EMTs or even surgical hospitals in a town this size, so doctors were forced to do what they could at the scene. A short time after being notified, local doctors Charles T. Newkirk and Maitland F. Newkirk, brothers who were well known and respected, arrived at the Block of Blazes. They had offices at 1006 North Water Street, in one of the buildings on the east side of Water between Fourth and Third Streets.

A native of Canada, Charles Newkirk, forty-two, was the more famous, having served in the 1860s as a physician for a provincial government in Argentina and in the Paraguayan army with the rank of major. In both countries, he was instrumental in battling epidemics, including smallpox, yellow fever and cholera. Afterward, he and his brother located to Bay

City in about 1868. Charles Newkirk actually had three brothers who were doctors, one of whom died in South America. He also had a son, Henry, who was a physician in Michigan. Newkirk was listed as a surgeon with the U.S. Army during the Spanish-American War and afterward with the Michigan National Guard. He died in 1909.

Maitland Newkirk, thirty-two, a graduate of the University of Michigan, had been a country doctor in Caro for a number of years before joining his brother in the Bay City medical practice.

When the Newkirks arrived at the Block of Blazes, they were informed of the situation and had the body removed to another room off the kitchen, where a bed with fresh linen was prepared. A few of the men who happened to be in the building were ordered to take hold of Knight until the police arrived.

Knight was described in the news accounts as short, about five feet, four inches, and thin in the face, with black hair, side whiskers and mustache and a "very sallow complexion."

Police searched the room where the attack took place, noting there was a near-empty liquor bottle on a nightstand along with some personal objects. Officers found the weapons used. One was the flatiron, which was coated with blood and hair, and the other a jackknife, which also was covered in blood.

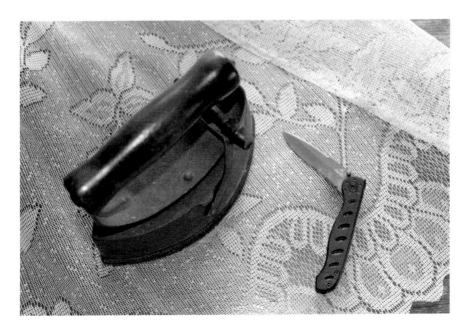

Lou Hall was murdered with a flatiron and jackknife similar to these. *Tim Younkman.*

A news reporter who was allowed into the place walked into the room off the kitchen where the woman was being tended by the two doctors. Besides her face being badly disfigured, she had sustained numerous stab wounds, and it was a wonder, the reporter noted, that she remained alive.

"The sight was enough to unnerve the strongest, and all present turned away with a feeling of abhorrence," he wrote.

The madam, Jennie Dubay, told the reporter that Lou Hall worked for her as a cook at the rate of $1.50 a week. It is interesting to note that in these houses, the women all had "job titles," so when asked, they could say they were a housekeeper, a maid or a cook. They might have performed some of those duties, but their real profession was obvious.

In his jail cell, Knight talked to a reporter about what he knew of the crime.

"When I awoke in the morning I was on the back side of the bed and Lou was lying on the outside, covered with blood and groaning fearfully," he said. "I immediately arose and almost fainted before I could get out of the room."

He did not admit doing the deed or knowing anything about it, but he didn't deny the idea that he killed her. The next few days found him suffering from delirium due to an infection in a large gash on his arm supposedly suffered during the night of the attack.

Meanwhile, Lou Hall clung to life for several days after the attack and attempted to speak but was not successful. It was noted that she had suffered a knife wound to the mouth, which prevented her from ever speaking the name of her attacker.

The night after the attack, Lou Hall's mother, a Mrs. Gould, most recently living in Fentonville (now Fenton, Michigan), arrived to sit at her daughter's bedside. A reporter who was present noted the woman showed no emotion, saying her daughter's death was preferable to the life she had been living. When asked if she would help tend to her daughter, she refused and left to return home. Lou finally succumbed to her wounds at 9:00 p.m. on January 5.

County coroner Henry Birney swore in a six-member jury panel for an inquest in which witnesses were called to testify. Gignac testified that Jabez Knight had a companion by the name of Charles Cook who resided in a room in Dolsenville, a neighborhood near the Dolsen Lumber Mill (an area around the modern-day GM auto plant on Woodside Avenue).

It was learned that Knight went to bed at about 7:00 p.m. on that night while Cook remained in the bar until well after 11:00 p.m. or midnight. Gignac said another woman, by the name of Rosa Wagner, also was in the house all night long with another man, identified only as French Pete. Knight

was known to have slept with Wagner on his first day in town, sometime around Christmas.

The coroner's jury verdict stated Lou Hall was murdered by "person or persons unknown."

A circuit court trial was held barely three weeks after the homicide. Despite the fact that there were other potential suspects, on January 22, 1885, Jabez Knight was convicted of manslaughter by a jury, which resulted in a fifteen-year prison sentence.

The questions remained: Who killed Lou Hall? Who had a motive to kill her? Knight didn't seem to have a motive, and the only one who did have one was Frank Hall, who could have arranged for one of his friends to kill her. But evidence in that direction never materialized.

That kind of crime was unique even for Hell's Half Mile, but the vice-riddled waterfront flourished openly for another twenty-five years and continued to be a seedy area all the way into the 1970s, when a concerted effort by the city eliminated the dens of prostitution and gambling and replaced them with parks, condominiums and tourist-friendly shops and restaurants. The area today is alive with shoppers, and Hell's Half Mile remains only as the moniker of a popular independent film festival held each year.

Chapter 2
THE POLISH WAR

It was Ash Wednesday 1896.

The lumber boom that had enriched the entire region was waning but still alive, and huge numbers of men were needed in all sorts of industries fueled by lumber. A large number of lumber mills remained in operation, with a variety of manufacturing plants, shipyards, shipping companies, railroads, construction companies and all sorts of service industries that required workers, the cheaper the better, meaning immigrant labor.

After the Civil War through the 1870s, a wave of Polish immigrants arrived in Bay County and most settled in what was called Portsmouth, a village adjacent to Bay City. It was centered on Twenty-second Street, which became Kosciuszko Avenue. The early Polish arrivals were Catholic and needed to attend church services. Most went to St. James Catholic Church on Columbus Avenue, which was considered the Irish church. At one point, there were so many Polish attending services that a Polish-speaking priest was assigned there. Still, the Poles wanted their own parish, and they got one: St. Stanislaus Kostka.

In 1875, a new church was constructed on Kosciuszko. The wood-frame building afforded the communicants services with sermons in their own language by a Polish pastor. It was expanded under the second pastor, Father Augustine Sklarzyk to make room for even more families.

The third pastor, also Polish, was Father Marion Matkowski, who was a take-charge individual. When the wood-frame building became too small

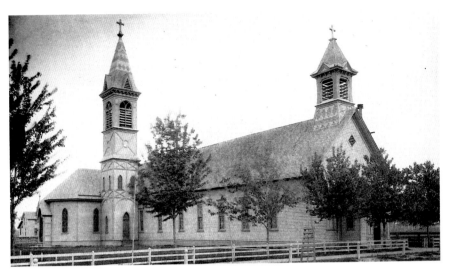

The original St. Stanislaus Kostka Catholic Church, shown here, was the first church for Polish-speaking immigrants. This structure proved to be too small and was expanded in the 1880s. *Bay County Historical Museum.*

again for the growing congregation, a fund drive that included tithing donations from each family and annual pew rents for maintenance raised enough money to build a new church.

The European-looking Gothic structure was completed in 1892 with Father Matkowski credited as the driving force in getting the new church constructed, and it still is one of the finest-looking churches in Michigan.

Also in the early 1890s, a second wave of Polish immigrants arrived in large numbers, settling in the South End, and began to attend St. Stanislaus. More Polish nuns were assigned to teach the increasing number of youngsters in St. Stanislaus Catholic School.

A rift developed since the older, established wave had become Americanized by speaking English and had become comfortable in the community, taking part in government and civic groups. They resented the intrusion of the new wave of immigrants, especially those who had not paid anything to build the new church and now wanted to take advantage of it without being obligated.

The new church had been opened for only a few days when a disastrous fire erupted along the riverfront in one of the lumberyards, and a firestorm roared through the South End, driven by gale-force winds. The story goes that while hundreds of families abandoned their homes fleeing with as much as they could carry in the wake of the fire, Father Matkowski donned

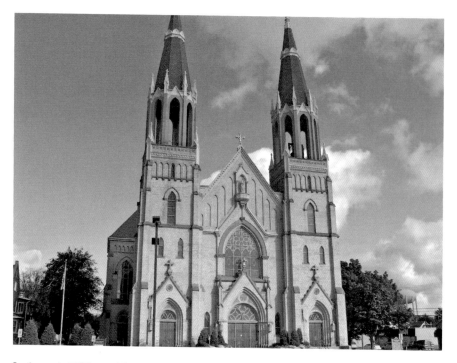

In the early 1890s, parishioners paid for a beautiful European Gothic–style church that quickly became the epicenter of the "Polish War." *Tim Younkman.*

his surplice, filled a bucket with holy water and headed toward the wall of flames. When he got to it, he sprinkled the holy water on the blaze, said a prayer and threw in blessed salt. Witnesses claimed that at once the wind died down, and by evening, the fire was under control.

Whether entirely accurate or not, that was Father Matkowski's reputation in the community, but on Ash Wednesday, February 19, 1896, that would change, kindling a different kind of firestorm.

The priest's rectory was next to the church, and Matkowski and his assistants employed a housekeeper, Francesca Mickiewicz, and her helper, a pretty fourteen-year-old newcomer by the name of Marta Cwiklinski.

The next day, an assistant pastor, Father Turski, and the father of Marta, Valentine Cwiklinski, confronted Matkowski with an accusation that he had molested the girl. They insisted that he resign his position and allow Turski to take over as pastor. Instead, Matkowski relieved Turski of his duties and said he would inform the bishop in Grand Rapids of his actions. Turski countered that he would go to the bishop and demand that Matkowski, along with his housekeeper, be removed.

While all this was going on, the general public was unaware of the nature of the problem, although rumors circulated quickly that there was a terrible rift between Matkowski and Turski.

However, in St. Stanislaus church circles, people became aware of the accusations. Some were astounded that anyone would make such an accusation against a priest, but others believed it and were very angry. Sides were drawn almost exclusively along the newcomer immigrants versus established immigrants. It wasn't until April that any details of a problem surfaced in the newspapers. On April 27, the *Bay City Times-Press* reported to a shocked community that St. Stanislaus was to be closed.

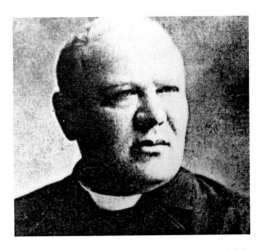

Father Marion Matkowski, who had been a widely respected pastor, was falsely accused of molesting a fourteen-year-old immigrant girl. *St. Stanislaus Catholic Church.*

The night before, a large gathering of newcomers who backed Mr. Cwiklinski and Father Turski met at Andrejewski's Hall, the second-floor room above Adam S. Andrejewski's saloon at 1029 South Madison Avenue. Turski said he had gone to Bishop Henry Richter and made his complaint but was sent back to St. Stanislaus, where he claimed the atmosphere was so bad that he couldn't stand it. He wanted a committee to see the bishop to demand Matkowski's removal. They referred to themselves as Anti-Matkowskis—or Antis, for short.

A committee of Antis, headed by Bay City alderman Adelbert Kabat, went to the rectory and talked with Matkowski. Afterward, the pastor announced he would leave St. Stanislaus immediately. He said he was not willing to keep putting up with complaints and demonstrations against him, and announced the school and church both would be closed in his absence until the bishop made a decision. Despite the story in the paper, the general public still didn't know the real cause for his leaving.

The paper printed a letter the next day from Father C.J. Votypka, who had been the assistant pastor for four years. He praised Matkowski and said criticism by Turski of the pastor was "humbug." He also referred to the housekeeper, Francesca Mickiewicz, as "a lady and a Christian."

On May 2, Bishop Richter, accompanied by Matkowski, arrived by train from Grand Rapids and was taken to St. Boniface Catholic Church and the offices of its pastor, Father John G. Wyss. There he met with a church committee from St. Stanislaus, but the details of that session were not disclosed.

The following day, Richter conducted confirmation services at St. Boniface and then at St. Joseph. He ordered all churches in the area to announce that Father Turski and all of those who back him and were opposed to Father Matkowski were "suspended" from the church. That drew the ire of the Antis, who gathered in the schoolyard to demonstrate their anger, threatening to take their appeal to Cardinal Francesco Satolli, the apostolic delegate in Washington, D.C.

Richter said he believed the congregation was misled by Turski and ordered the church and school to remain closed until further notice. Lost in all this seems to be the fact that the public still didn't know that Matkowski had been accused of molesting the servant girl.

One of the Anti leaders, Frank Ososki, at a mass rally in Andrejewski's Hall on May 7, claimed that the workingmen of the parish had paid good money for the church and were frustrated that they could not have a pastor of their choosing.

"We will be satisfied with any priest but Matkowski," he said.

Alderman Kabat surprised the crowd by saying he had led a delegation to see the Bay County prosecuting attorney Isaac A. Gilbert about having Matkowski arrested. Gilbert refused to seek a warrant but said he would talk to the bishop about the situation. The issue was taken out of his hands by other circumstances.

Matkowski was arrested on May 14, and it was the first time the public was informed of the nature of the crime. The warrant was signed by police justice William M. Kelley on a complaint by Valentine Cwiklinski that his daughter Marta was molested on Ash Wednesday evening by Father Matkowski in the parsonage where the girl was employed.

To avoid problems with crowds, Matkowski was arrested by Detective Benson in the offices of Matkowski's lawyer. Kelley also arraigned him in the law offices rather than have him taken to the police station. Bond was fixed at $1,000, which was posted by the attorneys, and Matkowski was allowed to go to the St. James rectory.

A two-day hearing in police court began on May 26 with Marta Cwiklinski testifying through an interpreter that what she had said about being molested by the priest was true, claiming she was called up to his room at 11:00 p.m. on Ash Wednesday. She said she stayed the night.

Matkowski testified that none of that happened; he had never asked her to come to his room, nor did she come to the room. He said he had no contact with her.

A friend of Marta's, sixteen-year-old Kate McNamara, a parishioner of St. James, said she was told by Marta that she had made up the story because her father put her up to it.

This was the first time that it was publicly revealed by the defense that the story of child molestation was fabricated, and it was clear to many that Valentine Cwiklinski may have been influenced by Turski. It also was beginning to become clear that Turski had mental problems.

A surprising news item appeared on May 27: Turski was no longer a Roman Catholic priest but had joined, as a priest, the breakaway Independent Catholic Church in Buffalo, New York. The church was not affiliated with Rome.

Housekeeper Mickiewicz testified that on the Thursday after Ash Wednesday, Marta left the house (meaning her place of employment) in the afternoon and did not give a reason for leaving. The housekeeper said she then hired another girl, Jennie Okon, sixteen.

Okon was called as a witness and said that on March 2, Father Turski did not come down from his room for dinner and Father Matkowski told her to take some food up to him. She said Turski let her in his room and asked her to make the bed for him. He asked where Marta was, and she said Marta no longer worked at the rectory. She began to make the bed.

She said: "He blew out the candle and closed the door, and caught me around the neck. He asked me if Marta was around here. I said no. He said, 'You be my Marta.' I broke away and ran down stairs and told the housekeeper."

She was afraid to tell Father Matkowski what happened, but the housekeeper continued to insist that she at least must tell her parents, which she did a short time before the hearing.

On June 4, Matkowski walked out of the police court a free man at 2:30 p.m.

Justice Kelley said it was his opinion at first that the Matkowski case should be tried before a jury, but after talking with the prosecutor, it became clear that the prosecutor would not continue with the case based on the evidence. Kelley said it was the prosecutor's opinion that Marta Cwiklinski's story was completely fabricated and that she and her family were under the influence of Turski, whom he described as "a bad man."

Matkowski attempted to get some of his papers from the rectory but was shocked to find it occupied by Antis who refused him admittance. The priest had two armed guards with him but chose to retreat rather than cause problems.

On June 18, it was reported that Turski has been advised (by persons unknown) to become a Protestant and to get married. He supposedly retorted that it was good advice, but he had no money. In order to get married, he asked his old friends back in Bay City to help him in his cash crisis. It was only a month earlier that he had joined the new independent Catholics in Buffalo. With this new, radical life change, his behavior had become even more bizarre.

He returned to Bay City, staying in the Fraser House, a hotel on Center Avenue, after lodging a few days with a friend, presumably an Anti, at the extreme south end of Michigan Avenue.

Meanwhile, armed Antis continued to occupy the church property, much to the chagrin of the Matkowski supporters. More trouble had been brewing, and menacing crowds milled around the perimeter of the property.

Bishop Richter arrived in Bay City on June 23 and planned to get a court order reclaiming the property in the name of the church that would allow authorities to arrest trespassers. There was some general apprehension in the community on June 26, when it was reported that an Anti-led Polish militia was being organized in the area surrounding St. Stanislaus and points south. Sheriff Alexander Sutherland toured the South End and witnessed the militia drilling. The leaders of the militia claimed they were practicing for the Fourth of July celebration.

The first real blood of the Polish War was spilled in the wake of the tragic death of Joseph Wiznerowicz, who fell from a tramway and was killed. As Wiznerowicz was a St. Stanislaus communicant, the funeral had to be held in St. James where Father Matkowski held services since St. Stanislaus Church was closed.

On June 28, 1896, the funeral service was packed with Polish people on both sides of the feud, including two women who were neighbors living a block apart on Twenty-fourth and Twenty-fifth Streets. As the service concluded, Mrs. John Naperalski said her neighbor began to abuse her because she was an Anti and should not attend a mass conducted by Matkowski, whom she disliked. The neighbor, Mrs. John Szezodrowski, struck the other woman in the arm. Mrs. Szezodrowski claimed that Mrs. Naperalski talked, whispered and laughed during the services, and she took her to task for it. She said Mrs. Naperalski hit her.

They were separated and were on their way home with their husbands when another confrontation developed, and this time, the men got involved. John Szezodrowski threatened to shoot Mrs. Naperalski "in the stomach." John Naperalski, twenty-five, got in front of his wife and

into the other man's face, and Szezodrowski shoved him. Naperalski struck the other man, knocking him down into a ditch, and proceeded to beat him. When Naperalski finished hitting him, he got up, and that's when Szedrowski pulled out a .22-caliber revolver, aimed at the man's chest and fired. Naperalski turned to run and was struck in the back by a second shot. However, because he was wearing a heavy coat, neither bullet entered his body, though they did cause severe bruising. At that point, Naperalski's father appeared, and Szezodrowski shot him, hitting him in the leg.

The two injured men got to their house on Twenty-fifth Street, and Dr. Newkirk was summoned to attend to them. Meanwhile, police officers went to Szezodrowski's house and arrested him. Szezodrowski claimed he fired his gun in self-defense.

Groups of people from both sides began milling around Twenty-third at Grant and at Van Buren Streets. There was talk that the Pros should get guns and kill off the Antis, and the Antis were heard to say they ought to get a rope and lynch Matkowski if they saw him.

At 7:30 p.m., there were three hundred men around George Kabat's hardware store on Van Buren and Eighteenth Streets. Meanwhile, the Pros were holding a meeting in St. James School with Matkowski in attendance. A youth acting as a scout ran in to say that a large gang of men was approaching the school and that he heard them say they were going to "wipe the place off the face of the earth."

Father Rafter of St. James quickly escorted Matkowski to the St. James rectory and sent for police, and a group of armed Irishmen from the parish arrived to help defend the property. Captain William Simmons and a squad of officers with the police wagon arrived, all armed with revolvers and clubs. They found an immense crowd around the school building, including women and children, and Simmons worried that if a riot developed a lot of people were going to be hurt.

Some men in the Antis claimed to have talked to Marta Cwiklinski and said that she had denied recanting her story. She insisted that it was true. The crowd was sufficiently whipped into a frenzy, all aimed at Matkowski. As they moved around the school, the officers jumped down from the wagon and formed a line, guns drawn. The crowd stopped moving. Simmons ordered the lights in the school to be extinguished to show there was no meeting going on. After a few more tense moments, the Anti leaders decided not to have a showdown, and the crowd dispersed.

The next morning, Szezodrowski, the man involved in the shooting, was released on bail pending a hearing.

An injunction was ordered by the Bay County Circuit Court against the Antis, which stated they were forbidden from conspiring to remove Matkowski or from interfering with his duties; plus, they were prohibited from occupying the church property.

In case the restraining orders were violated, the guilty parties were subject to arrest for contempt of court, and the sheriff served notice in English and Polish on each of seventy-six defendants listed. Once the papers were served on all of the parties, Matkowski attempted to re-open the church that Sunday, but the Antis vowed violence.

An Anti rally ensued with five hundred men who claimed the injunction wouldn't stop the majority from going on the church grounds or into the church itself. There were threats of arson, which prompted Sheriff Sutherland to order deputies to stand guard at the church.

Because of threats of the Antis, Matkowski declined to open the church on Sunday, July 12. Demonstrators who were prepared to disrupt the services melted away, but a large contingent of women, all armed with clubs, stones and pepper (powder), were stationed to prevent Matkowski from gaining entrance to the rectory, where the parish books were kept. There were new allegations by the Antis that Matkowski had embezzled money and that the proof of it was in the parish account books.

The sheriff's guards were withdrawn from the property, and Antis took over. A man identified as John Bakowski jumped over the fence on July 13 and declared himself to be the duly authorized guard sent by Richter and Matkowski. Moments later, he was attacked, beaten and stabbed in the hand before being thrown back over the fence and off the property.

Insurance companies reported that vandals had plugged the keyholes of fire alarm boxes around the church, which prevented any alarm of a fire. Insurance totaling $31,000 on the St. Stanislaus church was rescinded by the carrier. Fire officials declared that the fire alarm boxes near the church were to be examined each hour by firemen to make sure they were not disabled.

Meanwhile, Bishop Richter ordered Father Turski to go to the Trappist monastery in Gethsemane, Kentucky. It never was clear if he obeyed the order.

On July 22, Bishop Richter ordered Matkowski to remain as pastor and to retake his church. However, Matkowski did not reopen the church but continued celebrating Mass at St. James until August 14, when he announced he was leaving the city until the tensions died down. Two weeks later, he was granted an indefinite leave of absence from his duties and traveled to Europe. Meanwhile, the bishop ordered a young priest, a Father Lewandowski, to St. James in Bay City to assist in the Polish services.

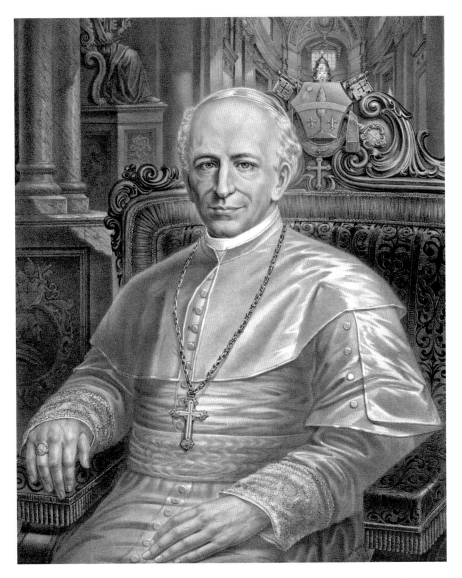

Pope Leo XIII took an interest in the unrest and rioting in St. Stanislaus parish and dispatched an envoy to investigate. *Library of Congress.*

The troubles at St. Stanislaus had reached the Vatican, and on September 10, Pope Leo XIII, who had taken an interest in what was happening in Bay City, authorized a representative, Father Peter Wawrzerniak, to investigate. He made a house-to-house visit and learned that all the Poles wanted hostilities stopped and the church reopened with a new priest in charge.

A new pastor was appointed, and Father Anthony Bogacki arrived from his former post in Posen, in Presque Isle County, and reopened St. Stanislaus for services on October 4. Bells announcing services rang again at St. Stanislaus on that Sunday without opposition from any faction. The euphoria was short-lived because Bogacki pronounced that all of the Antis must do public penance before being given absolution for their sins, which meant the souls of those Antis who would die without absolution for their sins were doomed to eternal damnation in hell.

That sparked a firestorm. More than seven hundred Antis (now Anti Bogackis) packed into Andrejewski's Hall to hear from a committee that had met with the bishop about this new priest. They decided to take a wait-and-see attitude for another week.

On October 24, the sheriff was called to the rectory to break up a crowd that had gathered. A committee had wanted to meet with Bogacki, but the priest would not meet with it. It was upset at the heavy penance the priest imposed.

The tensions boiled again on November 13 at the funeral service for Macj Szafranski, fifty-one, who lived on Madison Avenue between Fifteenth and Sixteenth Streets and was employed as a stave piler at William Peter's sawmill. He had died two days earlier, and it was generally known that he had been an Anti. The funeral cortege left the home and marched to the church for the 8:30 a.m. Mass. A number of those in attendance belonged to the St. Joseph Polish Benevolent Society, wearing their regalia, which included a black velvet sash worn over the shoulder and a silver cross on the front.

When the funeral procession reached the church, Bogacki met them, sprinkled holy water on the coffin and led the procession into the church. Once inside, he asked that the St. Joseph Society members remove their regalia. They refused and said they were a benevolent society, which was to give the widow $600 after the burial. Bogacki said there would be no service unless the regalia was removed and left the church for the rectory.

Outraged, the family left the church to return home, leaving poor Mr. Szafranski in his coffin in the church. Six members of the society stayed with the body along with about one hundred men and women, members of the Anti group. The society rotated six-man committees to hold vigil alongside the casket until such time as Bogacki performed the funeral mass, but he steadfastly refused to perform the service. He said the St. Joseph society could remove the body to St. Patrick's Cemetery to be buried there in consecrated ground without any further ceremony. Undertaker Frank

Wasieleski, 107 Washington Avenue, was asked by police to remove the body from the church for health and sanitary reasons.

The funeral incident caused several businessmen sympathetic to the Antis to purchase land for a new cemetery since the Antis complained they didn't want to be buried in the "Irish" St. Patrick's Cemetery. When Bogacki heard of this new cemetery land, located near Green Ridge cemetery on what is now Columbus Avenue, he was upset, declaring that the bishop would never consecrate this new burial ground. During High Mass on November 22, Bogacki allegedly called the Antis "hogs" and "wild Indians," which angered many, and a large portion of those communicants got up and left the church, joining an even larger mob milling around outside the church. They blocked the doors so the priest could not leave to go to his rectory, and the police were called by Pro-Bogacki men. When officers arrived, they found more than one thousand men and women blocking entrances to the church and keeping the priest a virtual prisoner. More police arrived and made their way into the church to talk to Bogacki.

The crowd grew more menacing, and the police decided to force a way through the crowd to the priest's residence, about thirty feet from the church door. They did not draw their guns but had their nightsticks ready. The Pro-Bogacki force also was armed, mainly with clubs but some had firearms. Then all hell broke loose.

The armed Antis forced the Pros off the church grounds, beating many in the head and face as they chased them. Some of the men had knives and some women had rocks while others were armed with nail-laced clubs called nail bats. Many people were seriously injured. The Antis retreated to the home of Matthew Janowicz, 915 South Farragut Street. Once again, Dr. Newkirk was summoned and tended to the wounded, most suffering head wounds. Other people who were injured to a lesser degree went to their own homes and family members treated them.

During this mêlée, Joseph Stichanski, a Pro-Bogacki man, who was guarding the priest's house, pulled his revolver and aimed at the crowd. Police officer Andrew Wyman shoved him back into the house. Had Stichanski fired the weapon, he would have been attacked mercilessly and possibly killed by the frenzied crowd.

Meanwhile, police officers were guarding Bogacki inside a small room in the church. Reinforcements were requested by officers with a plan to get the priest out of the area of St. Stanislaus and over to St. James, nine blocks to the north.

Police chief Murphy was informed that the Antis had picked a group of men to go into the church and take Bogacki out to the street. They also

One of the weapons of choice was a potentially lethal club like this one, known as a nail bat. Women especially favored it because it was easy to wield. *Tim Younkman.*

vowed to get into the rectory and take the parish books, which were being guarded by Stichanski, who still was armed.

The handful of police knew they couldn't hold out against a mob of over one thousand, so Captain Simmons negotiated a deal in which the priest and Stichanski would be allowed to leave the property unharmed. A hack pulled up, and Bogacki was able to escape the mob, being driven to the Rouech House, a hotel at 100 Fifth Avenue, a block from the police station. Stichanski walked away from the rectory and was not harmed.

Mayor Hamilton M. Wright arrived at the church to meet with Antis leader Frank Wasieleski, informing him that violence was against the law and, if it continued, he would have to act. He urged the Antis to protest peaceably because violence hurt the image of their cause.

The Antis allowed a cook into the rectory without incident, and they deserted the church premises. However, hours later, various informants told police and city council members that an attack on the parsonage was scheduled for dawn, possibly to bomb the residence. The mayor ordered all members of the police force to be ready at dawn in full gear and heavily armed, but day dawned without any violence, although some minor vandalism, such as rocks thrown through windows, continued.

Police arrested three men in connection with earlier rioting in which Andrew Biskupski was badly injured when struck in the head. The three men arrested were Valentine Kropski, Andon Foustyn and even seventy-one-year-old Michael Torkowski. The latter two were convicted in police court and fined fifteen dollars each after it was revealed that both men had clubs and both delivered blows with them to the victim's head repeatedly. Kropski was discharged without a conviction.

Warrants were sworn out for three other men in the riot. They were John Yachimovich, Kropski (again) and Joseph Beys, all for assault and battery. The trial of John Yachimovich ended in a hung jury on December 14, and a new trial was ordered. Action on the others was delayed.

The Polish War reached down into the ranks of the elementary school students when two eleven-year-old boys, Bernard Dumbroski and Frank Skrypzak, quarreled on the school grounds during recess on December 14, and Skrypzak used a jackknife to stab the other boy under the right shoulder. Dumbroski, of 812 Michigan Avenue, ran home and showed the wound to his mother, and she treated him. His father was enraged and went to the police, who promised to investigate.

Tensions were raised again when Bogacki announced that at the beginning of the New Year, all those who declined to pay pew rent had to vacate their pews. The Antis said they would be willing to pay the rent but would not do so until the backers of Bogacki were removed from authority on church committees.

New Year 1897 brought even more trouble when one of the Antis—Zenar Wroubleski, forty-two, the father of six, living on the corner of Fremont and Lincoln Streets in the South End—died of typhoid fever on January 2. He also was a member of the St. Michael Benevolent Society, which provided $600 to the widow and $50 toward the burial of a member. The society was on good terms with the parish, with a banner kept inside the church, but Bogacki refused to give Wroubleski spiritual consolation prior to and declined to bless the body after his death.

Instead of providing a funeral Mass, he closed the church doors and refused to have anything to do with the funeral. Bogacki said the sick man had refused last rites, which apparently was true. When the funeral cortege arrived at the church, it found the doors locked, and moments later, a wagonload of police, along with the mayor, arrived. The St. Michael's society members wanted their banner from inside the church returned to them and said that they would proceed to the new Polish burial ground, which they dubbed St. Stanislaus Cemetery. The mayor secured the banner

for them, and the crowd moved off in the direction of the cemetery, where the burial took place, even though the grounds had not been consecrated.

The war was about to escalate, and the story became a front-page headline, unusual for local news stories. This one in the Tuesday, January 5, 1897 edition of the *Bay City Times-Press* proclaimed: "Riot. The Poles Had One Today."

On that frigid morning, a committee elected by the Antis led a crowd of about five hundred men and women and went on the church grounds to confront Father Bogacki, ordering him to leave the parish for good. Special police officer James Fitzgerald, assigned as a bodyguard for the priest, would not let them into the parsonage. Someone used a club to smash a plate glass window in the door, and Fitzgerald drew his revolver and fired.

This sparked a barrage of missiles from the crowd—clubs, rocks, bricks and other objects were thrown through the rectory windows. The crowd surrounded the house and continued throwing things until every window and door was smashed to pieces. They tore the shutters from the windows, ripped doors from the hinges. Several shots were fired from the crowd at the house, and officers inside returned fire.

Several deputies on duty went to the windows and pumped bullets into the crowd, striking several of the Antis as they tried to run away. As the Antis retreated, Joseph Bartkowiak stood in the yard and was hit in the chest by a bullet. The mob stopped and turned around when Bartkowiak fell and surged toward the house, gaining entrance and smashing all the furniture. They demanded the lives of Father Bogacki and any men inside who were protecting him. Ink from a desk was taken and spilled onto the carpet, bookcases were smashed and a kitchen pantry was destroyed, the contents spilled onto the floor. A wheelbarrow was rammed through the kitchen door.

Bogacki, Fitzgerald and other deputies and several parishioners were on the second floor, all armed and ready for the final rush of the Antis. By now nearly every member of the mob had a weapon, and many had guns.

Police chief Murphy was informed of the riot and was told that at least a dozen men had been shot. He ordered all of the police officers and special officers to get their guns and nightsticks, loaded them in the police wagon and headed for the church grounds.

The Pros, mostly women, had organized into a mob on one side of the church grounds and had armed themselves with clubs, or nail bats, which also were the weapons of choice for the women on the Anti side.

As the wagon approached, the crowd surged to surround it. At that moment, two civilians jumped from the house window and tried to make a

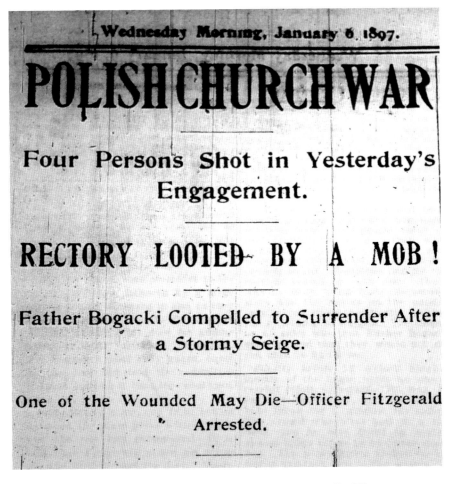

By January 1897, the violence had escalated, as reflected in this *Bay City Tribune* news story. Bay City Tribune, *January 6, 1897*.

run for it, but the mob caught one of them, identified as Joe Stachinski, and began beating him unmercifully. Police sprang from the wagon and went to his aid, preventing the crowd from killing him. Three officers picked him up and carried him to the patrol wagon, unconscious but alive.

Another man, Alexander Yonkowjak, tried to escape from the house and was caught, beaten and rescued by police, who also managed to take one of the Antis into custody. Chief Murphy, seeing that there were upward of one thousand people in the mob, decided to negotiate. He said he would get Bogacki out of the house but the Antis had to agree not to attack him, to which they assented. Meanwhile, Fitzgerald had exited the back door of the

house and was chased by members of the mob, who caught up to him and began beating him with clubs as he ran. He suffered head injuries but kept upright and was saved by a group of Pros who had a wagon, pulling him aboard and away from the crowd.

Because Fitzgerald was involved in the shooting, he was taken into custody by Murphy, and officers arrested Andrew Deska, one of the men who struck Fitzgerald.

The police led Bogacki out of the house and up Grant Street toward St. James rectory. He was not attacked by the crowd, although at least five hundred people followed him, shouting insults and threats.

Police said Frank Novakowski, of 908 South Michigan Avenue, was struck in the leg by a bullet fired from the house. He managed to get to his home, where a doctor was summoned. The bullet smashed a bone in his knee, and a piece of bone had to be removed along with the bullet.

Casmir Wisniewski, of 720 South Van Buren Street, had been one of the Pros guarding the priest inside the house, and when he emerged from the building, he was shot in the arm and clubbed with boards as he tried to escape. The bullet struck him in the right arm below the elbow.

Mrs. Joseph Turkowski, of South Michigan Avenue, was in the churchyard and was struck by a bullet through her leg. She limped home and was treated there by a doctor.

It also was reported that members of the crowd had gone into the basement, where a large amount of wine and liquor was stored. They handed out the bottles through a basement window to their friends, so some members of the crowd, at least, were fired up with alcohol on top of their religious zeal.

By 5:00 p.m., the riot had quieted, although a large number of Antis continued to hold the grounds. Meanwhile, fire chief Thomas K. Harding issued orders that all of his firemen should be armed in case they were called out for a blaze connected to the riot.

That night, Officer Fitzgerald was arraigned in police court on a complaint by Joseph Bartkowiak, charging him with assault with intent to do great bodily harm less than murder. An examination was scheduled for January 9, and bond was set at $800. Meanwhile, another warrant was issued against Bogacki for firing a pistol, the shot wounding Bartkowiak, and Andrew Deska, charged with assaulting Fitzgerald, was released for lack of evidence. Stephen Nowaski, charged with assaulting Alexander Yonkowjak, was released on $200 bail pending the trial, also on January 9.

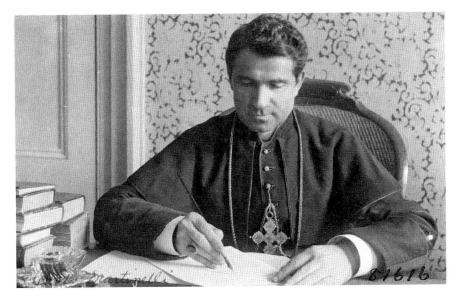

The Antis appealed to the Papal Legate in Washington, D.C., but Archbishop (later Cardinal) Sebastian Martinelli upheld the church position against them. *Library of Congress.*

The Antis then appealed again to the apostolic delegate, this time Archbishop (later Cardinal) Sebastian Martinelli.

On January 12, the Pro-Bogacki faction held a mass meeting at the new Washington Hall, on the corner of Washington and Eighth (now McKinley) Streets. The group was led by Alderman Augustus Elias. Two of the Antis tried to gain entry but were turned away by two guards. The meeting was called by leaders to advise all the Pros to continue to obey the law despite the provocations by the other side. The significance is that the Pros were becoming more organized by several respected leaders.

A police court jury found Stephen Nowicki guilty of assaulting Alexander Yonkoviak, whose head was struck repeatedly with a nail-laden club. Nowicki was ordered to pay a fine of thirteen dollars and court costs of eight dollars or serve forty days in jail. He planned to appeal, he said.

By January 13, Bishop Richter had seen enough and ordered St. Stanislaus School closed. The teaching nuns were ordered to pack their things and head by train for Detroit, and a detachment of armed policemen escorted them for their protection all the way to the railroad station. The sudden move left about five hundred children without a school, which was too large a number for the public schools to absorb all at once. It wasn't known at the time if other Catholic schools would accept them, or how much the parents would have to pay if they were allowed to attend.

At another mass meeting of the Pros at Washington Hall on January 17, the highlight of the night was the reading of a letter from Bishop Richter ruling on the appeal by the Antis about all of the church problems and the right to have benevolent societies associated with the church. Richter said his ruling was sent to Archbishop Martinelli in Washington, D.C., and that the new Papal Legate agreed with his decisions.

He disposed of the first charge that the church committees overseeing the budget were incompetent and misappropriated funds. The bishop said three of the five leaders of the Antis had been on those committees that had approved the handling of the church finances.

Bishop Richter also dismissed arguments that Father Bogacki used abusive language from the pulpit. The bishop noted the priest should not have used improper language but said it was the pastor's duty to "to inveigh against vice and to endeavor to suppress disorders in the parish."

Regarding charges that societies have been unjustly treated, the bishop pointed to the decree from the Fourth Provincial Council of Cincinnati regarding rights and duties of Catholic societies, which meant their formation and bylaws had to be approved by the bishop, the members had to be Catholic and their children were to attend a Catholic school: "Societies already approved remain approved and enjoy the privileges of Catholic societies as long as they remain faithful to their constitution and observe the laws and rules regulating such societies."

Richter pointed out that anyone in rebellion against the church authority could not receive the sacraments. He said some of the dissenters had presumed to lay down rules and guidelines for the priests, but that was the jurisdiction of the priests' superiors only.

He said a two-member committee, men who were not already on committees or on the parish council, would examine the church finances and would audit accounts each year.

On January 31, another Pro-Bogacki meeting was held in which it was announced that children readying for their first communion would be welcome at St. Boniface Catholic Church. It also was reported that delinquent pew rental fees at St. Stanislaus totaled $10,403, listing the names of those who owed the fees.

A possible violation of the U.S. Constitution developed on February 6 when the Pros obtained an injunction against two more Antis preventing them from going onto the church property. They were William V. Prybeski, publisher of the Polish weekly newspaper *Prawda*, and Adelbert Kabat, an Eighth Ward alderman. These appeared to be violations of the First

Amendment freedom of the press rights and of interfering with an elected city official performing his duties in representing his constituents.

The next day, another injunction was issued against the editor of the Polish newspaper, identified only as Laskowski. He went to the circuit judge Andrew C. Maxwell to find out how such an injunction could be issued in violation of the First Amendment. Maxwell said he had no knowledge of it since it was done by Bogacki's lawyers and held no validity.

A mass meeting of the Antis gathered on February 20 at Andrejewski's Hall and listened to the reading of a letter written to the church committee by Archbishop Martinelli. It stated that those who had caused the disturbances and caused trouble for the pastors of St. Stanislaus could not be considered Catholics until they ceased and desisted from their rebellious acts and that they had to accept the rulings and decisions of Bishop Richter. Despite the threat of excommunication, the Antis continued their defiant rhetoric.

Two men who were found guilty in Bay County Circuit Court of violating the restraining order were sentenced by Judge Maxwell. Charles Glaza was fined $250 and sentenced to six months in jail, and John Swiontek was fined $50 and sentenced to thirty days in jail.

On March 1, Judge Maxwell announced how fed up he was about the criminal activities associated with the St. Stanislaus feud. He said he had heard testimony in the injunction case by Alderman Kabat that the Antis were going to put guards on the premises day and night in shifts because they claimed a right to be there. Maxwell termed the action as "a conspiracy against the injunction of the court which is still in force, and I propose to put a stop to it."

He ruled that the sheriff would be put in charge of the property as a receiver and that he would proceed to serve attachments on all parties assuming any right to hold possession of the premises in violation of the injunction.

Sheriff Henry Guntermann took control of the church property at 7:00 a.m. on March 2, 1897. He summoned a number of deputies to assist in relieving the Anti guards who were on the property although they agreed to depart peacefully.

Meanwhile, Judge Maxwell ordered three more Antis to jail for contempt of court in violating the injunction. They were W. George Kabat, forty-seven, proprietor of the hardware store on the corner of Van Buren and Eighteenth Streets; Ignatz Buzalski, fifty-three, of 721 South Farragut Street; and Bruno Chudzinski, twenty-nine, of the South End. These three were identified as leaders of the Anti movement.

By 9:00 a.m., about four hundred men and women gathered around outside the grounds of the church property. The women were verbally abusive to the sheriff's men and even showed them nail bats they had under their shawls. The crowd thinned out after several hours, although the sheriff, sensing that trouble was brewing, asked Deputy Kinney to go downtown and gather up more deputies. The sheriff's men held the property all day and into the night without any major incident. He left four Polish deputies in charge overnight, and all four were Pro-Bogacki members.

However, the Antis were on the march again, this time attacking businesses and residences. On March 14, between 9:00 p.m. and midnight, eight houses and other property occupied by Pro-Bogacki people were attacked. Windows were smashed and property damaged.

Thomas Gilenecki, owner of a saloon and a grocery in a large double store on the corner of Michigan Avenue and Twenty-sixth Street, was one of the victims. A large crowd gathered outside his place armed with clubs and began breaking all the windows and smashing the shades.

The crowd moved on to Twenty-sixth and Monroe Streets and hit the house of Joseph Stachinski, who was one of the victims in the January 5 riot. Angry Antis smashed the windows of his home. The other victims included Joseph Linda, Frank Lange (a brick thrown through a window barely missed one of his young children), Joseph Dukarski's saloon (Twenty-second and Monroe Streets) with a door smashed in, Roch Andrzejewski's grocery (Twenty-second and Monroe) with a damaged front and Joseph Kusmisch (windows broken on his house on South Jackson near Twenty-second).

The crowd attacked the home of John Zaremba, the church organist, where someone broke a window with a fist, leaving a blood trail.

Bogacki announced on March 29 that he had resigned from St. Stanislaus and had met with the bishop regarding the situation. With the church closed, the parishioners continued to attend Mass at various local Catholic churches. Some ventured across the river to West Bay City and the German Catholic church on Seventh and Raymond Streets. That is the area near today's Holy Trinity Catholic Church on Wenona Avenue.

Another bizarre twist came on June 6, 1897, when the German Catholic Church caught fire. Alarms sounded at 12:30 a.m., when a sawmill worker on his way home spotted the blaze. The fire soon burned through to the roof, which collapsed at about 1:15 a.m. The church had been built four years earlier, with the second floor used for worship and the ground floor for a school. A news account quoted a young Polish man who said a number of Antis had been attending the services there and noted that the

congregation was not pleased and had made its displeasure clear. There were remarks about it in the Polish newspaper.

Officials said the fire was set with incendiaries. Antis denied having anything to do with it and blamed it on the Germans, who didn't like the fact that Bishop Richter had made arrangements for Poles to attend the church.

Meanwhile, the Michigan Supreme Court ruled that George Kabat was to be set free and was not guilty of contempt of court based on the evidence, although it stated the injunction was valid and other convictions were legal.

For the next few months throughout the summer, there were occasional problems, some skirmishes back and forth, but no major rioting occurred.

It would be another year before the bishop agreed to reopen St. Stanislaus with a new pastor and a promise from leaders of both factions to adhere to a truce to make the parish work again and to reopen the school for their children.

It is interesting to note that the official church history referred to this whole conflict as "an internal parish problem" and "a misunderstanding." It did record that Father Matkowski left the parish and went to Grand Rapids, where he was instrumental in building a new church, St. Isadore. The history also lists Bogacki as his successor, noting "his tenure as pastor was brief." It states the bishop ordered the parish closed until June 18, 1898, when he named Father Joseph A. Lewandowski as administrator and Father Anthony Bieniawski as his assistant.

The parish history continued: "The difficult situation was far from settled; however, Fr. Lewandowski managed to serve the spiritual needs of the parishioners. It remained for his successor to eventually bind up the wounds of discontent and division and to reunite the parishioners."

That cleric was Father Edward Kozlowski, who was appointed pastor on January 6, 1900. One of his goals was to unite the parish through building a new, bigger school, which opened in 1910.

However, there was a burning desire of many parishioners to form their own parish so they could officially split from St. Stanislaus with the blessing of the church. The ill feelings continued to foment under the surface, but no one seemed willing to return to the campaign of the previous violence. The agitation for a new parish grew.

Some local historians adhere to the idea that the creation of a new parish was just due to the natural increased membership of St. Stanislaus and that overcrowding was a problem. That part was true as far as it goes, but the ill will between the factions was undeniable. It was clear that if a new parish was approved, the Antis would be attending the new one even if it meant moving within its boundaries. The same was true

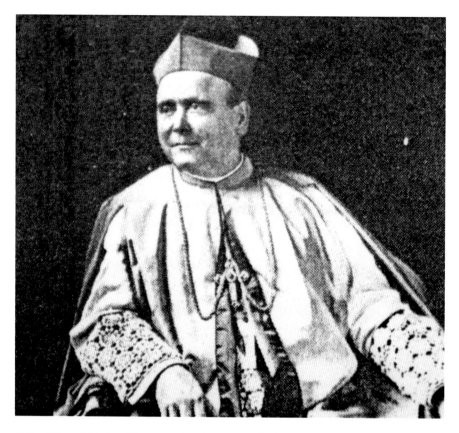

Father Edward Kozlowski was appointed pastor to obtain a truce and eventually restored order. *St. Stanislaus Catholic Church.*

with the Pros, who would move across boundary lines to get back into the St. Stanislaus parish.

Petitions were sent up the ladder to Rome, and studies were authorized to determine if a new parish was feasible. Since many of the Antis lived in the deeper South End, from the river to the townships, all below Twenty-seventh Street, the new parish was created in 1906 with a boundary at Twenty-seventh Street, and a church was built at the corner of Cass and Michigan Avenues. St. Hyacinth Catholic Church, named after a twelfth-century Polish martyr, opened in 1907, exactly ten years after the battles of the Polish War.

The attitudes between members of St. Hyacinth and St. Stanislaus continue to this day, although they will tell you they don't know why. They just know they don't like those in the other parish.

One of the results of the Polish War was the creation of a new parish, St. Hyacinth, at Michigan and Cass Avenues. *Tim Younkman.*

In an ironic twist, the recent cost-saving consolidation of parishes by the diocese has merged St. Stanislaus and St. Hyacinth parishes under the new name of Our Lady of Czestokowa, referring to the iconic Black Madonna painting that is housed in that Polish city.

Perhaps the reunification of parishes will create the final chapter of Bay City's Polish War, one of peace and reconciliation.

Chapter 3

AWOL FOR MURDER

The public is aware today of modern medical science advances in treating those who have been involved in military combat, not only from physical injuries but also emotional damage through identification of Post Traumatic Stress Disorder (PTSD).

The men who fought and suffered during the Civil War didn't have that medical benefit. As many as three hundred men from Bay County enlisted or were drafted into the Union army during the Civil War. One of them was Calvin R. Hills, thirty, who enlisted in August 1864 as a sergeant in Captain W.L. Lewis's Company B of the Twenty-ninth Michigan Infantry regiment.

It was believed that Hills was on furlough from his unit toward the end of the war when he showed up in his hometown, the village of Portsmouth, an area adjacent to the southern city limits of Bay City. He had been involved in several battles, especially around Murfreesboro, Tennessee, and in defense of the Nashville and Chattanooga Railroad.

Historians have noted the Union combat forces were under heavy attack on several occasions when the remnants of the western Confederate army attempted to retake territory lost in Tennessee and to force the main Union force under General Sherman to quit Georgia and turn back north toward Tennessee. The Twenty-ninth Michigan fiercely guarded the rail lines between Nashville and Chattanooga, which were providing needed materiel to forces up and down Union lines. It was evident later that something happened to Hills, perhaps seeing his buddies wounded or

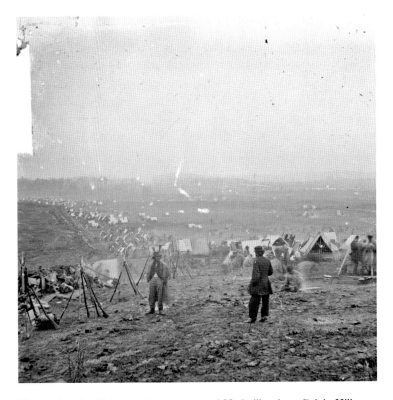

This depicts the Union deployment around Nashville where Calvin Hills was serving. *Library of Congress.*

killed or having to kill the enemy in face-to-face encounters. He may never have known the true meaning of fear until then.

Local historian Jim Petrimoulx, who has done extensive research into the area's Civil War veterans, uncovered some information about what really drove Hills to return to Bay City before being mustered out of the army. Petrimoulx learned that it was after one of the battles that a friend of Hills from Bay City, also in the Twenty-ninth Michigan Infantry, happened to meet up with him somewhere around Nashville. The news his friend brought was a shock: Hills's wife had run off with his children, left their home, sold off their possessions and disappeared—with another man!

It was more than Hills could stand. The war should have been over but wasn't and more killing was coming. He had to get home to find out what happened and to find his wife and children. For a day or two, he fumed and finally broke. He deserted his unit and headed north. He might have hitched

a ride on a northbound train, but in any event, he arrived in Bay City in March 1865.

He did find that his wife had left their rented home and sold the furniture, taking their children with her when she left town with an unidentified man. He approached a family friend, Moses Spencer, who lived in the neighborhood and received some of the details. Spencer, thinking Hills was home on furlough—not that he was AWOL from the army—invited him to stay with him and his family.

Accounts in one of the earliest newspapers, the *Bay City Journal* on March 9, 1865, revealed what happened next: "SHOOTING AFFAIR IN PORTSMOUTH—A MAN SHOT BY A SOLDIER."

The shooting occurred in the village of Portsmouth, an area beginning at about Eighteenth Street and incorporating much of the land from the river eastward to Michigan Avenue and south to about Fremont Street. The shooting location wasn't exact, but it appeared to be in the area of Lafayette and Broadway Streets.

The newspaper article noted that "a man named Spencer," no first name given at that moment, was the victim of the shooting on Monday, March 6, in Portsmouth. The article said Hills did not attempt to escape but waited for the authorities to arrive.

The unpleasantness began in a dispute over furniture, specifically, the ownership of some furniture Hills claimed belonged to him. He told authorities after the shooting that a woman by the name of Mrs. Mary Baker had come into possession of furniture that Hills had owned before entering the army and leaving the village. He said he knew that when his wife and children left the area, his wife illegally had sold some furniture to Mrs. Baker. But, he stated, his wife didn't have the right to sell the possessions without his approval. He claimed that he wanted his furniture back from Mrs. Baker and went to see her about it. However, Mrs. Baker said he could not have it and that she had bought it in good faith.

According to witnesses, he told her he was taking the furniture, and she called to a neighbor for help to have Hills evicted from her home. A man named Henry Ellison walked over and entered the house. He was followed by Spencer, who had been working outside next door, cutting wood slats for a bed. He was holding one of the slats when he walked into Mrs. Baker's home to find out why she was calling for help.

Mrs. Baker implored the men to throw Hills out the door, but Hills pulled a gun from his belt, showed it to them and put it back in his belt, again stating he was taking the furniture. It was obvious to those in the house that even

if Hills took the furniture, he had no place to put it; however, by then, he was beyond the point of reason.

During the confrontation, Spencer claimed he wasn't afraid of Hills or his gun because they were friends and tried to convince him to leave the property. He then made a move either toward Hills or to reach for the wood stick, and that's when Hills pulled his gun again and fired, striking Spencer in the chest.

As Spencer staggered out the door, Hills began to drag furniture out of the house. He made no attempt to escape. When Spencer fell down unconscious, his wife and daughter, hearing the gunshot, ran from their house next door. Some witnesses said Hills helped them carry Spencer to their home and had someone summon a doctor.

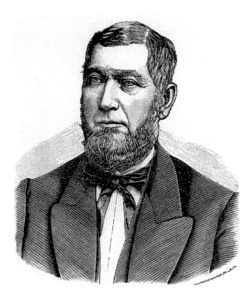

Judge Albert Miller, founder of Portsmouth village, talked Hills into surrendering. *Bay County Historical Museum.*

Mrs. Baker said she went outside her house and happened to see Judge Albert Miller, a prominent businessman and founder of Portsmouth, and called to him to help disarm Hills.

Miller went into the house and talked to Hills, convincing him to surrender his weapon and submit to arrest, which he did.

Meanwhile, Dr. Jeffry R. Thomas arrived to treat Spencer. He said it appeared the bullet went in between the third and fourth rib and damaged the heart. He said he attempted to trace the bullet's path, indicating it went through the right ventricle and ended up in the left lung. He said the wound was "necessarily fatal."

Miller escorted Hills to the county jail to await a hearing, and prosecuting attorney Luther Beckwith decided to charge Hills with first-degree murder. Sergeant Hills was taken before Justice Randall that afternoon, and testimony was given by a few of the witnesses.

Neighbor Henry Ellison testified that he knew Hills and described what happened.

> *I was in my barnyard when the fuss first commenced between him and Mrs. Baker, across one block. Mrs. Baker called on me for assistance. I saw the defendant and Mrs. Baker and her little boy, George, and a little child, no one else. I took it slow because I did not think there was any great trouble.*
>
> *She came out a second time and called—said to "hurry! Come into the house and assist me." And I quickened my pace and came in. Defendant stood on the north side of the house at the back part of the room—he could not get quite against the back part on account of a table against the wall. The dispute seemed to be about some furniture goods.*
>
> *The defendant spoke: "These goods I am going to have. I am going to take them out." Mrs. Baker said "No, you shan't."*

Ellison said Hills threatened to shoot anyone who helped her.

> *Spencer then came in and said, "What, what! Can't you get along without shooting women?" Spencer stood in front of him. I saw [Hills] turn, and saw that he had a pistol, and I told Spencer to take care, that he had a pistol.*
>
> *Spencer said: "I don't care. I am not afraid of the pistol." Hills said: "You ain't damn you!" He shot him at that instant.*
>
> *Spencer turned around and says: "Hank, he's done it."*

Defense attorney T.C. Grier concentrated on the possibility that Spencer had a wooden club in his hand when he approached Hills, thus making it a case of self-defense. Ellison said that he believed Spencer did walk in with a piece of wood in his hand but that he set it against the wall and never picked it up again. He also testified that Spencer made a step with one foot toward Hills when the shot was fired.

Witness Mary Baker testified that she had lived in Portsmouth for about one year and was a neighbor of Hills for a short time before he went into the army. She recounted the details of the incident:

> *I saw him first near 7 o'clock this morning at my house. He sat and talked with Mister Jester from Quanicassee some time. When Jester went away, [Hills] commenced talking with me about his wife and children. I had bought some furniture of hers before she went away after he went into the army. He seemed to get excited talking about Spencer and his family. I told him that I wanted him to go out of my house—that I considered he was abusing me and my neighbors. He said he would not go.*

> *I called to Ellison and Spencer to put [Hills] out of the house. I am a widow woman and alone—when I stepped back from calling them, he took his revolver form his belt and held it towards my breast and told me that if I opened my lips again he would blow me through. I couldn't tell what passed. He'd held the pistol within a foot of my breast. I was so stunned that I couldn't recollect what took place when Ellison came in.*
>
> *Ellison made a remark that it was no mark of a gentleman to be threatening a woman, or something to that effect. Spencer came in a short time later.*

Mrs. Baker said Hills threatened to shoot Spencer.

She said Spencer put down his stick when he walked into the room. Spencer said he wasn't afraid of the pistol or of Hills.

She said Hills then raised the pistol and fired.

"Take that," she quoted Hills as saying.

"He [Spencer] turned towards me and fixed his mouth as if to spit, and then spit blood upon the door step," she testified. "He stopped several steps outside of the door, leaned forward, and fell a short distance from the door."

She said Hills then went about removing the furniture that his wife had sold to Mrs. Baker from the house.

She said Spencer was carried home and that Albert Miller then arrived. Hills had returned his pistol to his belt, and it remained there until it was taken from him. She said she asked Miller to take the gun and get Hills out of her house.

"Miller asked him for it," she said. "He [Hills] said he would not give it up."

They went outside, and a crowd gathered around. It was then that Hills surrendered.

After Dr. Thomas testified about how the bullet had killed Spencer, Justice Randall ordered Hills to stand trial in circuit court.

Calvin Hills went on trial in April in circuit court presided over by Judge Jabez G. Sutherland. A jury found him guilty of first-degree murder based mainly on the testimony of Mrs. Baker and Henry Ellison.

Sutherland sentenced Hills to life in prison at hard labor and solitary confinement without parole. Hills died in prison from a fever, possibly typhoid, six years later, in 1870, at the age of thirty-six.

Chapter 4
YOUNG BOY'S DEATH CHANGED THE LAW

In the last half of the nineteenth century, the Bay City business moguls had accumulated immense wealth in lumber, shipping, shipbuilding, mining, heavy industry and manufacturing, and they had accomplished nearly all of it with the help of child labor. In those industries, children were employed in often dangerous situations at low wages.

One study of wages showed sawmills employed boys on various jobs at only half the pay of a man doing the same work, or about $0.75 a day. Girls employed in domestic jobs might only earn $1.50 a week.

Child labor was a fact of life for most of the nineteenth century, and many children were maimed or killed in the process; however, nothing much was done to change the practice. Coal mining was one industry where children as young as ten were employed, often as breaker boys. In this role, they sorted impurities from the coal as it flowed down a conveyor line into bins, an occupation quite dangerous to their hands and with the added danger of being supervised by armed men ready to beat them if they slacked off. Others performed various tasks in the mines that also were dangerous.

Boys working in lumber mills lost fingers and hands, either through cuts from saws or from having them crushed by logs or when stacks of cut lumber shifted. Boys working at the coal mines in southwestern Bay County often became ill from toxic fumes or suffered injuries in accidents.

Even when child labor regulations were imposed, prohibiting the hiring of youths under sixteen, many employers circumvented the laws. Other

Breaker boys worked long hours inhaling coal dust as they sorted slabs in bins with supervisors standing nearby ready to beat them if they appeared to slack off on their tasks. Child labor was common throughout the local industrial history. *Library of Congress.*

industries depended on workers between sixteen and eighteen, whom they also paid half wages.

On December 18, 1894, four teenage boys and another worker were killed in an explosion at the Russell Brothers & Co. planing mill and box factory in West Bay City. According to reports, a boiler in the building on Kelton Street in the Salzburg district of the city exploded at about 9:30 a.m.

The dead included George Pfund, seventeen; Albert Huebenbecker, eighteen; John Calcutt, twenty-four; Albert Rahn, sixteen; and John Braun, eighteen. Injured were Charles Doege, twenty-two; Roe Hudson, sixteen; and Fred Wildanger, seventeen.

Investigators said the four were in a fire room near the boiler eating a lunch, as was their custom on their morning break, when the boiler exploded. The blast mangled all four of them to the point of making them almost unrecognizable. Several of the boys' mothers who lived in the Salzburg area and felt the explosion rushed to the mill, but some of the workers kept them from going into the makeshift morgue set up in one of the small buildings.

The three who were injured were in another room nearby and were hurt as the blast hurled bricks, boards and metal in their direction.

While Bay City's new city hall, shown here, was under construction in 1894, an eleven-year-old worker was killed when he fell seventy-five feet from a ceiling area inside the structure. *Tim Younkman.*

A committee selected to examine the circumstances of the explosion said the boiler failed because of its being "overtaxed" with an extreme pressure load to run the mill machinery. The public expressed concern but not outrage at the death of the youths.

Something that did outrage the public came that same year on October 23, 1894, when a young worker not yet twelve years old was helping in the construction of the new city hall on Washington Avenue. He and another youth were working seventy-five feet above the floor at the underside of the roof, securing by wire the roofing tiles being laid on the outside.

Investigators said they were told it was a standard procedure for the boys to work in such a precarious position, but it also was the way the roofing material was commonly installed. Robbie Waldo, who was to turn twelve on November 1, was attaching the wires from the tiles to nails he was driving into the wood frame. At about 8:30 a.m., Robbie was reaching to attach the wire and lost his balance. He fell from his scaffold, bouncing off several beams, before free-falling onto the cement floor seventy-five feet from the ceiling.

A worker reported hearing him gasp for breath as he died. Robbie still clutched his work hammer in one hand.

A police wagon was summoned, and the remains of the lad were taken to his home at 218 Jefferson Street, only a few blocks to the east. His mother was told ahead of time that he was being brought home, but she was so distraught as to be inconsolable.

A coroner's inquest confirmed that the death was an accident rather than some defect of equipment, although nothing was said of the age of the deceased or of the lack of any safety equipment.

The next day, Bay City alderman Edward Kroencke introduced a resolution to the common council that demanded a restriction on child labor. In his resolution, Kroencke noted that Robbie Waldo, who also sometimes used the name of his stepfather, Rifenburg, was a lad of eleven. The resolution required that any contract the city entered for public works be with employers that did not have any employees under the age of sixteen.

The resolution was accepted unanimously and went into effect immediately, being the first such ordinance in the state of Michigan. Similar resolutions and laws in other states were enacted late in the nineteenth century and around Michigan by the end of the decade, but most were ignored by contractors.

It would be another eighty-four years before the State of Michigan enacted the Youth Employment Standards Act, banning underage workers from hazardous sites. According to a report by the U.S. Department of Labor, two million children younger than fifteen years of age were employed in 1910.

The City of West Bay City actually passed an ordinance requiring employers not to have anyone employed under the age of fourteen, and that law was used to charge William Goldie Jr., owner of Goldie Manufacturing Co., with having an underage employee.

The charge stemmed from an incident on June 5, 1903, in which employee Edgar Peterson lost part of his hand when it was crushed in machinery. Two doctors were called, and they operated on the mangled right hand, severing two fingers and the thumb all the way back to the wrist.

Justice of the Peace Frederick Neumann arraigned Goldie on a charge of employing thirteen-year-old Peterson in violation of the ordinance.

Chapter 5
DEATH OF A LUMBER BARON

It was a quiet September evening when one of Bay City's lumber barons, Franklin Eddy Parker, a forty-nine-year-old accomplished businessman and industry leader, went out for a stroll.

It was the long Labor Day weekend. Businesses would be closed again on Monday, so Parker was not in a major hurry to get home to bed.

Parker had been born into the prosperous Eddy lumbering family through his mother, Laura Matilda Eddy, and he had partnered with relatives in several sawmills and lumber operations in Bay City. In other words, he was wealthy and resided on Center Avenue, the smart address for many in the well-to-do set.

On that Sunday evening, September 4, 1916, Franklin E. Parker and his wife, Mary, had entertained in their home at 1406 Center. Among those who attended were relatives Charles F. Eddy and his wife who lived across the street in the same block.

Parker was energetic and often went for walks before retiring for the night, and on this evening, he walked the Eddys back to their home at the corner of Center and Lincoln Avenues, where the Central Fire Station is today. According to Mrs. Eddy, Parker then continued on to visit a friend nearby and was walking east back toward his home when two shots rang out.

According to police, Parker was walking on the sidewalk across Center opposite from the Eddy home when two men approached him from behind and ordered him to raise his hands. He turned his head and attempted to swivel his body around when one of the men fired a .32-caliber

Wicked Bay City, Michigan

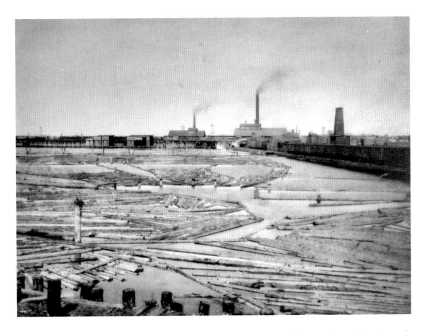

Lumber barons like Parker made their fortunes with sawmill operations like these along the river, where the floating booms, ready for the cutting season, were herded. *Bay County Historical Museum.*

Parker was gunned down as he strolled through this quiet, upscale Center Avenue neighborhood. *Bay County Historical Museum.*

pistol, the bullets striking him in the back and arm. Stunned by the gunfire and the burning pain, Parker continued to turn to face his attackers and instinctively swung his walking stick at them.

The fact that he still was upright seemed to unnerve the two bandits, who turned on their heels and began running north on Lincoln. Police noted that if robbery was the intent, they failed to take anything. In the meantime, the wounded Parker staggered into the street and attempted to wave down two motorists who sped past him. Finally, a third driver, identified as automobile salesman William E. Bouchey, saw the man in the street and went past him, but as he did, he recognized Parker and turned around, motoring back up to him. He got out and asked what was wrong.

"I've been shot," Parker groaned and stumbled to the car. Bouchey helped him into the vehicle, and they drove up the block to Parker's home. He helped the lumberman get inside the house, where his family could help and call for a doctor. In the meantime, other people who heard the shots called police.

Mrs. Eddy said when she heard the shots, she looked out her window to see a man stumbling in the street. She didn't recognize him as Parker and thought it was someone who was intoxicated.

"He was walking around in a circle," she said. "I heard him say 'I've been shot.' He repeated this two or three more times and just then an automobile came by. He motioned for the driver to stop but it went right on."

She said eventually a car stopped, and the man was helped. She later learned from another neighbor that the man in the street was Parker.

The doctors who came to the Parker house began tending to the wounds, and it seemed, for a time, that the victim was responding to the treatment, although they were not able to remove the bullets. Later, though, his condition worsened, and he was taken to Mercy Hospital. An X-ray showed that the bullet that entered his back was lodged in his liver. The other bullet hit the right arm and moved up into the shoulder but was not considered life threatening.

He again seemed to rally for a brief time, but after a few hours, his condition declined. Surgery was required. Authorities reported that he was wheeled in to surgery and, at about 6:00 a.m., died on the operating table. Doctors reported that the bullet not only had penetrated the liver but also had damaged the kidney, and there was extensive internal bleeding that was difficult to stem.

The police acknowledged there were no new solid leads in the case, but the police chief said more than a dozen suspects had been rounded up. All of them had alibis and were released.

DEATH OCCURS AT 6 O'CLOCK MONDAY AT MERCY HOSPITAL

Victim of the Hold-up Men More Seriously Wounded Than at First Supposed.

ONE BULLET HAD ENTERED HIS LIVER AND A KIDNEY, CAUSING HEMORRHAGE.

Sank Very Rapidly After Reaching the Operating

The public learned of the death of lumber baron Franklin Eddy Parker after he was shot down on Center Avenue. Bay City Times-Tribune, *September 5, 1916.*

Parker was taken here, Mercy Hospital, where he expired. *Bay County Historical Museum.*

Some important information did surface about the night of the shooting. Police said their immediate investigation discovered that a home at 1212 Park Avenue occupied by Blaine Bristol had been burglarized prior to the shooting. That was about twelve blocks from the shooting scene.

They said thieves broke in by cutting a screen and opening a side door. They drew on the tablecloth a skull and crossbones and outlined a hand. Police weren't quite sure to make of it but realized it had been done for a reason. The thieves found two small cash banks and took them to the basement to open them. About ten dollars in cash was taken.

"The men who robbed the home of Blaine Bristol helped themselves to both beer and whiskey," said police chief George Davis, quoted in the *Times-Tribune*, "and there is the possibility that the job was done by amateurs who, their brains fired up by liquor, set out on a more reckless career. We do not know, of course, whether Mr. Parker was shot by professional holdup men or by local talent in that line, but it seems quite apparent that whoever did the shooting lost their nerve when the victim did not fall after the second shot was fired. Consequently, no attempt was made to search him for valuables."

Mr. Parker was an interesting figure in Bay City's history, though his name is not as well known as some of the other lumber kings.

Franklin Eddy Parker was born in Bangor, Maine, on January 28, 1867, to Edward Everett Parker and Laura Matilda Eddy Parker. He attended the Boston Latin School, where his parents had moved when he was still quite young.

Based on a brief biography in the *Bay City Tribune* in 1912, Parker attended Harvard University, graduating in 1889. He also took some postgraduate law classes.

He may have been at odds with his family since he didn't go right into the lumber business. Instead, he struck out on his own, going out West to work for the Montana Union Railroad in Butte, and later, he became chief clerk in the general agent's office of the Union Pacific Railway. He came to Bay City, where several of his relatives were engaged in the lumber industry, in 1891 and was employed as a commercial agent for the Flint & Pere Marquette Railroad. Two years later, he was promoted to superintendent of the water lines for the same rail line in Ludington.

In 1894, he returned to Bay City and finally went into the lumber business as secretary and treasurer of the Eddy, Sheldon Co. He also held the same position later with the Mershon, Schutte, Parker & Co. lumber firm. In 1908, he took over as president, and the company became Mershon, Eddy, Parker & Co.

While he was working for the railroad, young Franklin Parker had his Bay City offices in the Pere Marquette station. *Bay County Historical Museum.*

The *Tribune* noted that Parker served as president of the Saginaw Valley Lumber Dealers Association and as a trustee of the National Wholesale Lumber Dealers Association. He was also elected association president, evidence that he was nationally known and respected.

He married Mary Beecher Bishop of Salt Lake City, Utah, in 1882. They were the parents of one son and two daughters: Franklin Eddy Parker Jr., Mary Bishop Parker Smith and Laura Loranne Parker.

Parker was a vestryman with the Trinity Episcopal Church and held membership in the Bay City Club, Saginaw Country Club, Bay City Country Club and the prestigious Harvard Club of New York.

Charles E. Pierce, former Bay County prosecutor and a defense attorney in a number of criminal cases, told reporters that he believed the crime was committed by youths rather than hardened professional criminals.

> *I have found that the code of professional criminals is never to take a life unless it becomes absolutely necessary to protect their own. Here is a case where the object of the footpads was given no show whatever. He was*

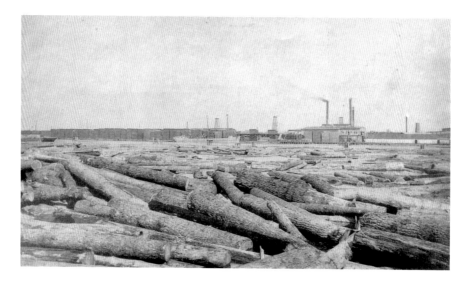

The abundance of timber on the river gave rise to powerful lumber barons who respected Parker enough to elect him leader of their association. *Bay County Historical Museum.*

simply shot in the back, after which the perpetrators hastened away. The motive may have been robbery, but if it was, the highwaymen gave no indications of it by their actions. The act was one of the most cowardly in the annals of local history.

His words might have held the truth in most cases, but when it came to the South End Gang in Bay City, his observations proved unflinchingly wrong. This appeared to be the gang's first major violent act but not its last. However, police did not link the shooting to the gang—at least, not right away.

Three days after the shooting, the Bay County Board of Auditors authorized a $500 reward for information leading to the arrest and conviction of those responsible for Parker's murder.

In a related incident, police said they were notified by William Mitchell, owner of Bay City Auto Co., that he was driving west on Fifth Avenue toward Johnson Street on the night of the shooting when someone tried to get him to stop his car. He said a man was in the road and another on the sidewalk, somewhat in shadow. The one in the road had raised his hands trying to get him to stop the car, but he continued forward, forcing the man to jump out of the way. Mitchell said he reported it just in case the men he saw were the ones involved in the shooting.

Citizens began offering money to authorities to add to the reward, and by September 9, the reward amount had reached $3,000. Flyers were printed informing the public of the reward, but no one came forward.

Day after day—then month after month—went by, but there was no progress. Leads dried up. A year passed and then two and three. The case went cold with zero new leads, and the files were put in a cabinet—not forgotten, but simply inactive, waiting for a day when some glimmer of information might appear.

That glimmer came in a strange way over four years later. It wasn't only the fact that there was a lead but also the source of the lead that surprised police. A career criminal, a robber and murderer convicted in the slaying of two men during a South End bank robbery, offered information to an officer taking him to prison.

Aloysius "Long Legs" Nowak, twenty, a member of the South End Gang and one of four gang members to rob the bank on January 15, 1921, claimed that the gang leader, Steve Madaj, was the one who had pulled the trigger and murdered Franklin Parker.

Steve Madaj was identified as the killer of Franklin Parker. *Bay City Times-Tribune, February 7, 1921.*

On February 4, 1921, after Nowak and the three other gang members were sentenced to life in prison for the bank robbery and murders, he talked to one of his guards, a Bay County deputy sheriff escorting him on the train to Marquette. Nowak embellished the story somewhat, but that didn't rule him out as the second man who attacked Parker. In any event, he knew Madaj well and actually was one of his trusted lieutenants, running a crew of his own. He claimed Madaj had knocked Parker to his knees and then shot him. He said after the shooting, the gang members ran down Lincoln Street to Fifth Street, which meshes with the statement given by motorist William Mitchell who said a man tried to stop his car on Fifth.

The Parker murder might have been one of the early attempts at armed robbery by Madaj, but he quickly honed his skills and committed numerous robberies and murders later on. He was in the Bay County jail awaiting trial in another series of robberies when his gang hit the bank and he was told of Nowak's statement.

Madaj admitted he had told gang members that he had shot Parker to bolster his image as leader, but he really didn't have anything to do with it. However, based on Nowak's accusation and further investigation by Bay City police and even a private investigator from Grand Rapids hired by local banks, evidence turned up pointing to Madaj as the one who killed Parker, and Madaj was charged with first-degree murder.

Investigators looked for evidence besides Nowak's statements and came up with another source that was even more solid—Madaj's accomplice.

The trial started in Bay County Circuit Court on March 14 with the painstaking process of selecting jurors, running through several panels before defense attorney James L. McCormick and prosecutor William A. Collins ran out of challenges and agreed on a jury.

Observers noted that the courtroom was overflowing and that more than three hundred people lined the sidewalks between the jail and the county building, across Center Avenue from each other, as seven armed sheriff's deputies walked the gantlet of the curious citizens making sure no one got too close to Madaj.

Once in the courtroom, Collins told the jury that Madaj's companion involved in the shooting, a gang member named Stanley Delestowicz, would testify and name Madaj as the shooter. Delestowicz had already pleaded guilty to being involved in the robbery-murder. He testified that Madaj said they were going to go along Center Avenue until they found someone to rob. They saw Parker and moved quickly up behind him, ordering him to put his

hands up, and as Parker was about to turn around to face them, Madaj fired twice with a .32-caliber pistol.

He said they were surprised that Parker didn't fall down right away and were worried the noise would alert the neighborhood, so they ran off, heading north on Lincoln to Fifth Street and then north again to the railroad crossing, where they split up. Delestowicz said he ran all the way to the fairgrounds on the eastern city limits and hid for a while to make sure no one was coming for him. He then walked down another set of tracks to Tuscola Road, where he met up with Madaj. He said they walked down Columbus to Farragut Street, where they split up again.

Madaj took the stand next and claimed he was not even in the city when Parker was murdered. He claimed that he was in Cleveland, Ohio, after being laid off from a Munger farm as a farmworker. He said he didn't even associate with Delestowicz until sometime during 1917.

The jury was given the case to deliberate in the late afternoon and, ninety minutes later, returned with a verdict of guilty of murder in the first degree. For a brief moment as the jury verdict was read, Madaj showed his first signs of emotion, dropping his head and wiping at his eyes, but then he straightened up and regained his indifferent pose.

Bay County circuit judge Samuel G. Houghton sentenced Madaj on March 17, 1921, to two terms of life in prison without parole, one for the Parker murder and the other, for which he pleaded guilty, for attempted prison escape when he tried to break out of Jackson Prison from an earlier auto theft conviction.

A heavily guarded Madaj was taken by train immediately to Marquette Prison to begin serving his two life terms.

Chapter 6
RISE AND FALL OF THE SOUTH END GANG

By many accounts, including those of the gang members themselves, the South End Gang was organized by Steve Madaj, a World War I veteran, although his criminal career had started before his enlistment.

He and many other young men and teenagers often hung out in the South End's Roosevelt Park or in a local pool hall. Madaj was older than most of the others, and they tended to follow his lead.

While he was the kingpin, it was a loosely organized outfit, and many of the young men went out on their own, as did Aloysius Nowak and Ramon Olejniczak, who were involved in breaking and entering homes or businesses, while others strong-armed people for cash. One of the more popular endeavors that occurred all the way into the Roaring Twenties was stopping cars in the street like modern-day highwaymen and robbing the occupants at gunpoint before sending them on their way.

However, according to Bay City historian and author D. Laurence Rogers, Madaj also involved himself in stealing cars simply for joyriding, using them to get them to places around town where they could pull some other jobs, including bank robbery and murder. At any given time, there were ten or twelve members who went out in twos and threes and sometimes larger crews to conduct their thefts and robberies.

One of Madaj's early crimes was with pal Stanley Delestowicz in the robbery and murder of Franklin E. Parker, and both killers had escaped justice for nearly four years.

Madaj joined Michigan's 128th Ambulance Co. from Bay City after America entered World War I. *Bay County Historical Museum.*

One of the 128th Ambulance Co. trucks is on display in the Bay County Historical Museum. *Tim Younkman.*

Madaj enlisted shortly after America entered the war in 1917 and joined the 128th Ambulance Company of the Michigan National Guard—all Bay County men who went overseas to France and Belgium for the duration of the war. (One of the ambulances used in the 128th is on display in the Bay County Historical Museum.) Madaj returned home with his unit in early 1919 and lost little time in retaking control of his gang.

The former Bay City Savings Bank on Broadway at Thirty-second Street now is abandoned and in disrepair. *Tim Younkman.*

While they had plagued neighborhoods with burglaries and some of the smaller shops with break-ins, they also went back to their old ways of stopping autos in the street and robbing the occupants.

The gang moved back up to the big time on Saturday, January 15, 1921, when four masked gunmen entered the Broadway branch of the Bay County Savings Bank, robbing it of $4,380 in cash and several liberty bonds. While inside the bank, one of the bandits opened fire, killing Martin L. Debats, a local grocer, and Labra M. Persons, an agent for New Era Life Insurance Co., both well-known residents of the South End.

Police said the men arrived at the bank in a stolen car and parked it along the Thirty-second Street side of the bank. The car was left running, and all four of the gang went into the bank. Witnesses told police that the four men entered the bank at about 8:25 p.m., just before the bank was to close. One of them, who also was the driver, stepped back outside to act as a lookout. Police suspected there might have been a fifth robber involved, but that never was verified.

Almost at once, gunfire erupted, and the robbers shot down the two men and grabbed any money they saw in the cash drawers before running back outside, jumping into the getaway car. The bandits kept firing as they left, shooting at pedestrians and anyone on the sidewalks, although no one else

was hit. Witnesses reported that at least one of the men stood on the running board and kept shooting at people and buildings.

The car later was abandoned near St. James Church on Columbus Avenue. The car, a Buick "big six," belonged to John M. Miller of Fifth Avenue and Birney Street, where it was stolen from his driveway at about 7:00 p.m. Police said when the car was found, there were two bullet holes in the back seating area that were made by the gunmen themselves as they all shot their guns wildly, waving the weapons in all directions.

Meanwhile, nearby store owners, hearing the gunshots, had called police. Two cars full of officers arrived, while other policemen were deployed to search for the getaway car.

Branch bank manager Fred M. Loll said neither shooting victim had a chance because the gunmen opened fire as soon as they walked into the bank. He said they scooped up coins and paper currency. At the time of the holdup, he and a bookkeeper, William Grimmer, were behind the cashier's desk. He said Debats had come in with the daily deposit from his store across Broadway from the bank, and Persons had walked in to get change for a twenty-dollar bill. Both customers' backs were to the door when the men came in and opened fire.

Loll said each of the gunmen held pistols and wore black masks of a shiny material. They ordered Loll and Grimmer to get face down on the floor. After the bandits left the bank, Loll said he immediately called for medical help from nearby doctors. Drs. Roy Perkins and Edward Huckins arrived quickly but found Persons had died, and once they started working on DeBats, he survived only a minute or two before expiring.

Police also said they talked to eight men who were in the International Order of Odd Fellows (IOOF) meeting room in the same building and who had rushed outside to see what was happening as soon as the first shots were fired. They immediately encountered a lookout on the sidewalk who began firing in their direction. Some of them retreated, but two others advanced and ran across the street, bullets flying over their heads. No one was hit, but the bullets penetrated the front wall of a pool hall.

Bank manager Loll said he believed the robbers may have been known to the two victims and surmised that was why they were shot. He said the two men, because of their businesses, knew just about everyone in the South End. It was likely they might have recognized one or more of the robbers, and the robbers knew it.

The police investigators noted that neither of the dead men was robbed and both had their wallets intact in their pockets.

Nuns from a convent near St. James Catholic School told police that they saw the Buick pull up between the school and their new convent and watched five men get out of the car. When police arrived, they said they found the motor was still hot and the doors open. The nuns said the men had run south on Jackson Street.

The *Bay City Times-Tribune* reported that about the time police found the Buick, a number of self-appointed vigilantes began a search for the bandits. The civilians all were armed with pistols and rifles and recruited more and more people in the South End to join them. All took to their cars and began a block-by-block scouring, looking for anyone out of place or who appeared suspicious.

The problem was that these robbers all were South Enders and resided within a few blocks of one another. Even if the vigilantes saw them, they wouldn't have been out of place. Police said there were at least one hundred vehicles involved in the vigilante patrols, much to the chagrin of local officers.

The victims were known and well liked by residents in the South End and elsewhere in town. It came as a terrible shock when word spread that they had been killed. They had worked hard all their lives, and to have had their lives snuffed out in an instant on a cold winter Saturday night was intolerable. That's why the vigilantes took to the streets, even though they hindered police working on catching the bandits.

Martin DeBats, sixty, was one of the best-known businessmen in Bay City, operating his grocery store at 1823 Broadway. He had served as a city councilman and was president of the Valley Home Telephone Co., past president of the Bay City Grocers and Butchers Association, and a member of the Masons, Elks and Odd Fellows. By faith, he was a Methodist. He was married and the father of two sons and a daughter.

Labra M. Persons, sixty-nine, had worked as a young man at a general store in the South End, and then was a traveling salesman for fifteen years before going into the insurance business. He also was a Mason and Knights Templar and attended the First Church of Christ Scientist. He was married and the father of one son.

A reward set up by the banks in town totaled $4,000, and it was raised to $8,500 a day later with pledges from the city and county governments and the Bay City Rotarians.

Still, leads followed by the police had dried up, although they fully suspected the South End Gang of Steve Madaj as being involved. Nothing bad happened in the South End without some or all of the hoodlums from the pool halls and Roosevelt Park being involved.

Bay County circuit judge Samuel Houghton presided over the South End Gang's hearings and sentencings. *Bay County Historical Museum.*

from the other two in custody. Authorities said Walkowiak, who was housed in the Tuscola County jail in Caro, also confessed to other detectives but that he pointed at Nowak as the leader of the four.

When he was told of Walkowiak's statement, Nowak admitted to being the shooter, claiming it was the fault of the two victims because they did not put their hands up fast enough. He spoke matter-of-factly about the crime and even said he talked about the news of the robbery with his parents over the dinner table the next night. He laughed when he related how his parents were so angry that they said whoever did the killing should be strung up.

Walkowiak was named as the actual driver of the car because he knew how to operate the high-powered vehicles.

It later was determined by police that Walkowiak entered the bank with the others but then stood in the doorway as a lookout and opened fire on the Odd Fellows members when they emerged from the side door of the building.

Police said the married sister of one of the men came forward with money her brother had given her for safekeeping. She said she told him to put it in a bank, but he said he couldn't because the police would suspect something was wrong. She told police that bothered her and then she connected the dots, realizing it was the stolen money from the bank robbery. The bag contained about $800.

Nowak said each of the men got $1,000, and Walkowiak was given an extra $100 for driving the car.

Kubiak, aware that the others were talking, finally confessed to Bay County sheriff Theodore Trudell and described the details of the robbery-murder, corroborating much of what investigators had learned from the others and from their own probe. He said:

> *I got acquainted with Steve Madaj at the Lewis Manufacturing Company's plant where we both worked for about a year. In the latter part of last August we met Walkowiak and Olejniczak, we talked things over and decided the world owed us a living and we were going to get it. All of the boys were out of a job but me and we started out one day feeling gay and someone said we should go on a joyride. We all agreed to this and we went. Nothing happened to us so we thought we would take some more automobiles and were stealing them right along until we decided to do some holdups and wake the town from its slumbers.*

He said they broke into Breen's Hardware to steal guns and ammunition before embarking on the holdup plan. They stole a car at Sixth and Van

Buren Streets, and Madaj took the wheel and certainly was in charge of the gang. He said the next night they robbed the Standard Oil station, and afterward, Madaj warned them if any of them got caught to keep quiet—or else. He said they were afraid of Madaj and believed he would kill them if they talked.

A little while later, Madaj was arrested, and all of them were afraid that he might finger them as the robbers instead. With Madaj in custody, Nowak assumed control of the gang, and they decided to hit a bank, debating which one until all agreed on the Broadway bank.

They stole a car and went to the bank, with Nowak jumping out and running up to the door, but he found it locked. They had to wait for the next day.

The gang members stole another car, the Buick, and went back to the bank, but when they looked inside, they saw a number of women in the lobby. Fearing the women would scream, the robbers circled the bank until the women left; however, there still were three men, so they waited another ten minutes. Finally, they could wait no longer since it was near closing time, so they prepared to go in.

He said that Nowak noticed one of the men in the bank was DeBats and that he knew him. He quoted Nowak: "I'll teach DeBats a lesson for hanging around the bank when I want to transact some business."

This statement alone seemed to show that Nowak killed DeBats on purpose with premeditation.

An extraordinary court session occurred in the early morning hours of Friday, February 4, 1921, as circuit judge Houghton arranged to hold an arraignment at 1:30 a.m. Given the events of vigilantism right after the bank robbery, the judge wanted to avoid any idea of a lynching and to prevent other gang members from interfering or attempting to break their friends out.

Houghton ordered Nowak, Kubiak and Olejniczak to be brought before him with their attorneys. All three entered pleas of guilty to charges of first-degree murder and were sentenced immediately to spend the rest of their lives in prison at Marquette.

Walkowiak also pleaded guilty to the charge but since he was the driver of the getaway car, Houghton said he would consider the sentence at a later time.

As far as addressing the other three, Houghton pulled no punches: "You know, and knew at the time that you killed the men, that it was a serious crime, and from the statements that some of you have made, it was the most deliberate, cold-blooded offense against humanity ever committed during my connection with this city."

Once the sentence was handed down, the three felons were taken to a waiting police car, and they were driven to Kawkawlin, where, by prior arrangement, the 2:10 a.m. Michigan Central Railroad train was stopped and waited for the three men to be taken aboard with armed guards.

Even though it was supposed to be a secret session, word had leaked out, and there was a crowd gathered outside the Bay County Courthouse.

The judge clearly was upset at the gangsters' demeanor since the men smirked and mumbled to one another throughout the hearing. Houghton also brushed aside a complaint from Kubiak's attorney James McCormick, who said he was not allowed to talk to his client prior to the hearing because no one would tell him where the prisoners were being housed. He was told he had to request a client meeting through the judge because the men were being held secretly to avoid a mob taking them out and hanging them. McCormick was upset but realized there wasn't much he could do about it.

On the trip to Marquette, Nowak talked to a sheriff's deputy guarding him, and that's when he pointed the finger at Steve Madaj as the killer of lumberman Franklin E. Parker in 1916. The deputy reported the accusation to the Bay City police.

On February 5, a day after the early morning court hearing, police chief George V. Davis and prosecutor Collins revealed the arrest of four more gang members in connection with the August 8, 1919 burglary of the Bay City Iron Works in which $4,250 worth of liberty bonds and war savings stamps were stolen from a safe.

The four men were identified as Joe Pletniak, brothers Steve and Leo Dukarski and Ignatz

Police chief George V. Davis pursued all of the gang members, gathering evidence in numerous robberies and murders. *Bay County Historical Museum.*

Nowak, and all of them confessed to the police, Davis reported prior to their arraignment.

The confessions indicated that the crew leader, Steve Kubiak, who had just been sentenced to life for murder in the bank robbery case, had planned the Iron Works job and got a large chunk of the money once the bonds were fenced.

Police said Joe Dukarski was not involved in the actual break-in, but did supply the gang members the combination to the safe and accepted some of the stolen loot.

Only Pletniak waived a hearing and agreed to have his case sent to circuit court. The other three were to face a hearing on the evidence. Bond of $10,000 was set for each man, and all were sent to the jail.

At about this same time, another gang member, Stanley Delestowicz, had been arrested on some petty crime but confessed to police that he was an accomplice in the slaying of Parker in 1916 and named Steve Madaj as the shooter.

He was secretly housed in a jail outside Bay City pending further investigation and court action. It didn't take long to get warrants because authorities already had the statement by Nowak also accusing Madaj of the murder.

Delestowicz was to be the star witness against Madaj when he went to trial in March. The trial ended with a conviction of first-degree murder, and Madaj was sentenced to two life terms in Marquette.

At the time of his sentencing, Judge Houghton also sentenced Walkowiak to twenty-five to fifty years in prison for stealing at least five automobiles. All other charges against him were dropped.

Gang member John Poinkowski, eighteen, confessed and pleaded guilty to armed robbery charges in connection to several cases in which citizens were robbed and at least one was wounded. Poinkowski said Aloysius Nowak was the leader in the holdups and break-ins of several stores.

But the gang wasn't finished. On April 23, 1923, Madaj and fourteen other inmates instigated a daring escape from Marquette Prison, and he made his way back to Bay City. Despite the fact that authorities were on the lookout for him, he eluded police.

Two months later, on June 18, Madaj and his gang struck. At 2:15 p.m., he and another gang member walked into the Bay County Savings Bank branch on Kosciuszko Avenue and announced it was a holdup. A third gunman acted as a lookout near the getaway car.

They tied up the cashier, identified as Michael Dardas, using a piece of wire and ordered two clerks and four customers into the bank's vault, and the door was closed. Reports indicated Madaj got away with about $4,000

in cash. Later, Dardas told police one of the robbers was Madaj, whom he recognized. Several of the customers also identified him.

The bandits fled in a new Hudson touring car, speeding away east. Madaj probably didn't realize that the vault door didn't lock. Once they had left the building, those inside the vault opened the door and called the police. The car was spotted by a number of people, so police were able track part of the getaway route. The Hudson traveled east on Columbus Street to Ridge Road and continued out several miles turning onto Vassar Road before the trail grew cold. The Hudson was believed to have been stolen from a residence on Hamilton Street in Saginaw a day earlier.

Once the word was out that Madaj had robbed the bank, several friends and relatives told police they had known he was in town, with some indicating it was only for a few days. Police believed he had been in the area the entire time since his prison escape.

Police chief Davis said investigators believed Madaj and his pals were responsible for stealing a number of cars in recent weeks and possibly several break-ins.

As the days and weeks passed, there was no report of Madaj being seen locally. It was possible that he had left the city to lie low in Saginaw or on one of the farms where he had worked as a youth.

Meanwhile, life continued in Bay City, where more news was generated as Christmas approached. Bay City's history was filled with violence, especially during the lumbering era, but in all those years, not one police officer had been killed. Several had been wounded, but none died.

That laudable record was shattered in the early hours of December 18, 1923, when Patrolman Frank Kowalkowski was gunned down as he was about to call in an arrest in Bay City's South End.

That area of town had been dominated by the South End Gang for years, but since so many had been arrested, the gang's stranglehold on the community seemed to have loosened.

The district was a nearly self-contained neighborhood row of shops and businesses including drugstores, butcher shops, grocers, engine repair and other services and retail operations. Kowalkowski himself lived in the Polish neighborhood at 717 South Farragut Street, not far from St. Stanislaus Kostka Catholic Church.

Traditionally, policemen would walk the business areas at night, checking to make sure the doors were locked and no one was hanging around closed businesses.

Wicked Bay City, Michigan

Broadway today still contains rows of commercial buildings that appear much as they did on the fateful night Patrolman Kowalkowski was murdered. *Tim Younkman.*

Kowalkowski was a thirty-one-year-old family man, with a wife and eight-year-old daughter, Germaine. He was a lifelong resident of Bay City and had been employed by the city's Parks Department before becoming a police officer. He had been on the job for only a month, with almost no training or experience. Still, his job was not complicated. He patrolled the Broadway business district, which really started at Fremont Street and ran south for five blocks. At the end of another block was Cass Avenue, where other businesses were located.

On that cold December night, Kowalkowski was on patrol near the Harris Drug Store on the corner of Thirtieth and Broadway. It was after midnight when he noticed movement down Thirtieth Street toward the rear of the store. He hurried along the side of the building to an alley where he saw two men loitering near the door. They had no explanation as to what they were doing there and acted suspiciously enough that he pulled his weapon. He told them that they both would have to go into the police station for questioning. He said they would walk with him to the nearest police call box for a car to come and pick them up.

It wasn't reported if they had anything in their possession, although it seemed clear they had been attempting to break into the store. It wasn't known if he checked them for weapons, but common sense and normal procedure would indicate that he did, meaning that neither was armed.

Patrolman Kowalkowski was a rookie, but he grew up in the South End in a tough ethnic neighborhood, many of the youths being first-

Kowalkowski confronted the two suspicious characters in this alley behind the Broadway businesses. *Tim Younkman.*

generation Americans of immigrant parents. However, as tough as he might have been, he was inexperienced and in situations where lawmen are confronted with law-breakers even today, they depend on their training and experience to have the confidence about how to handle them.

It was likely he did not know the pair, but it was odd that he did not write down their names or at least ask them to identify themselves.

Standard procedure today would have required the two in custody to at least be handcuffed together, but they were not. Instead, he marched them back up to Broadway and began the trek south six blocks to the police call box at Cass Avenue. On that route, they would have passed three blocks of businesses and a few apartment houses and then the east edge of Roosevelt Park between Thirty-fourth and Thirty-fifth. The park was a well-known hangout for the South End toughs.

At about 1:10 a.m., they had reached Thirty-fifth Street, a block from the call box, when, it seems, one of the men lagged for a few seconds. As Kowalkowski slowed down to allow the suspect to catch up, someone moved up behind him with a .32-caliber automatic pistol and fired at least seven shots. Four of the bullets struck Kowalkowski, one below each shoulder, one in the heel and the fourth in the side. Another shot hit a metal button and

This is where Kowalkowski fell at Broadway and Thirty-fifth Street after being shot four times. *Tim Younkman.*

didn't penetrate through. Officials later said two of the bullets were steel-jacketed and went through his body.

Kowalkowski, with four bullet holes in him, wasn't killed instantly and staggered all the way across the street before he fell. He had the energy to raise his own weapon and fire at the men running away from him, but the bullet missed. He then fell back down in excruciating pain, unable to move.

A woman living nearby heard the gunshots and looked out her window. In the dim street lighting, she could make out someone on the ground and called the police station to report it. When officers finally arrived, they helped get him to Mercy Hospital on South Water Street, where he was treated by Dr. V.L. Tupper. Kowalkowski lingered for a few hours but expired at 8:25 a.m. with his wife at his bedside.

Prior to his death, Kowalkowski had remained conscious much of the time and was able to say he had two youths in custody, though he had not gotten their identifications nor could give a good physical description of them. He said he wasn't sure which building they had broken into, but he thought they had been into one of them in that block.

Police began searching the neighborhood but turned up no suspects. At dawn, they began retracing Kowalkowski's steps from Thirtieth Street, where he had encountered the two youths.

Operating on the belief that there had been a burglary in that block, officers discovered Hohes Hardware Store had been entered through a skylight. They removed the frame in hopes of finding fingerprints. It was learned that a number of .22-caliber cartridges and some pliers were stolen.

Police chief Davis searched the area of the shooting and discovered seven .32-caliber shells. He said he also found one of the steel-jacketed bullets that had hit the button on Kowalkowski's jacket and was stopped.

Neighborhood residents said they heard shots—some said five, some more—and that they heard men running away to the east and then north. Once again, people looking out their windows might not have seen much. Streetlights were on, but they were spaced out and didn't provide as much illumination as today.

Officers found three youths in the area and brought them into the station for questioning after finding one had a .22-caliber pistol on him. However, the police did not believe these three were involved and released them.

Police chief Davis spoke of Kowalkowski's character: "He was a clean young man and a very good officer. He was anxious to become a police officer and was developing into a very capable and able patrolman. He died in the performance of his duty." Other officers on the force also praised his work ethic. In his memory, the flag in front of city hall was lowered to half-staff.

At first, it was believed Kowalkowski had been struck three times; it wasn't until Coroner Henry M. Simon had conducted an examination of the body that it was learned that Kowalkowski actually had been struck by a fourth bullet, entering the body on the right side and passing through to the left breast.

A friend of the officer told reporters that Kowalkowski remarked on the day before the shooting, possibly in a joking matter, about his assignment: "I've got a bad beat now. I'm liable to get shot up."

The news spread throughout the state, and three men were arrested in Flint. When detectives went there to interrogate them, they discovered the three were black and had no connection to the Bay City crime. Officers also were informed that three Bay City youths were picked up in Lansing, but it turned out that they had gone there looking for work and also had nothing to do with the murder.

Bay City investigators were convinced that it was a youth or two who had broken into the hardware store because they found the stolen items stashed in a woodpile in the Hansen-Ward lumberyard. The determination was made due to the type of cheap things stolen, including safety razors, two cheap and one better-grade harmonicas, fifteen small jackknives, several hundred rounds of .22-caliber bullets, a couple flashlights and a mantel clock.

It was likely that the youths apprehended by Kowalkowski had broken into the hardware store, taken their loot to a prearranged hiding spot and returned to the alley to break into the drugstore.

On December 22, more than one thousand people attended the funeral service in St. Stanislaus church and, in long lines outside, offered comfort to Kowalkowski's wife and daughter. They all traveled to St. Stanislaus Cemetery on Columbus Avenue for the burial. Observers remarked on the large contingent of police officers from the area in the funeral procession, along with many city officials.

Kowalkowski was raised in the South End and attended St. Stanislaus Kostka Catholic Church and school. He was the son of John and Rosa Kowalkowski of 2419 Fraser Street. He had two brothers and a sister.

The investigation dragged on as Christmas came and went. So did Easter Sunday 1924 and the Fourth of July. Another Christmas went by. There were no suspects and no solid leads.

All the police had was a belief that the youths most likely belonged to the South End Gang.

A half century later, the police were called by a man who said he was dying and wanted to clear up the policeman's murder. He claimed it was his brother who committed the crime, although the brother was deceased. Police checked into the claim, but nothing definitive came of it.

However, another theory has been forwarded by Bay City author D. Laurence Rogers, a former newsman who has penned a number of books on local history, including a study of the famous Birney family. He also has delved into the stories of the notorious South End gang.

So, who was in the park that early December morning? Who was so vicious as to shoot a police officer not once but seven times in the back, mortally wounding him?

Rogers said he believes Kowalkowski was gunned down by Steve Madaj, who still was the boss of the South End Gang, even though he had been sent to prison for murder in 1921.

"I think it was Madaj who came up behind Officer Kowalkowski and shot him numerous times," said Rogers pointing to his considerable research into Madaj.

The scenario could very well have been that the two youths Kowalkowski had in custody were gang members and knew where Madaj was hiding after his prison escape and the bank robbery.

Rogers said he believes Madaj saw the policeman marching the two youths up the street and realized that, if they were taken into the police

station, they could very well spill the beans about him, which could lead to his capture. The easiest way to stop that from happening was to take out the policeman before he could get to the call box to phone in the arrest and get backup to come to the South End.

Madaj certainly would have had the steel-jacketed bullets needed to take down a man, even with the smaller-caliber .32. After shooting him repeatedly, knowing he hit him four or five times at least and seeing him drop, Madaj and the others ran off. Although Kowalkowski managed to fire a round at them, they had to believe he would be dead before anyone reached him.

Rogers said the scenario is just a theory, although it fits with everything that happened that night. It also matches Madaj's vicious reputation. The fact that Madaj was a coldblooded killer, Rogers said, just adds fuel to the idea that he could kill a policeman without a second thought.

In any event, Madaj eventually found his life of crime in Bay City coming to an end. He was captured at the home of a relative on October 17, 1924, nearly eighteen months after his escape, and was the last of the fifteen men who broke out of Marquette prison. He also was suspected of killing a Munger farmer before his capture, although he was not charged.

Madaj wasn't done making news. On July 10, 1931, he and another inmate, Detroit gangster Eddie Weisman, who helped him break out the first time, were caught attempting another prison escape.

Authorities said the two men had improvised explosives and several guns but were found out before they could make use of them.

In 1962, Governor John B. Swainson granted a request to release Madaj from prison after serving forty-one years. Swainson was lobbied by former army buddies of Madaj to release him since he had served in World War I. It was an election year and Swainson agreed, perhaps hoping for some veterans' votes and those of Michigan's Polish community.

Bay City's Violet Eichorn, who was a teenager when Madaj was captured in 1924, wrote to him in prison and waited for him to be released. They were married following his release, and both lived into the 1980s. They are now buried side by side in Elm Lawn Cemetery.

Chapter 7

THE CASE OF THE MURDERING MOGUL

The news was shocking enough. A twenty-eight-year-old woman, supposedly from Grand Rapids, had endured what was called a "criminal operation" in her Bay City hotel room.

At 3:00 a.m. on Tuesday, April 1, 1902, her lifeless body was taken from the room by Undertaker George N. Ewell. That was where the mystery truly began.

The woman had registered at the Fraser House on February 19, 1902, as May Morris of the Furniture City. Sometime later, a man arrived at the hotel and paid her bill, and the two left together, according to a news account in the *Bay City Times-Press*.

She was described in the report as "a fine looking woman with piercing eyes and very dark brown hair."

A month later, on March 19, she returned and checked into the hotel under the same name. Ten days after that, she was dead.

Ewell prepared her body, put her in a coffin and had her taken to the train station for shipment to Battle Creek, where relatives lived on a farm. An unidentified young man accompanied her body.

Her death aroused the suspicion of police chief Nathaniel Murphy, and when he was on the case of a possible criminal venture, the bad guys were in for a world of hurt. He was to be aided by longtime veteran officer Captain Andrew Wyman. Also involved in the investigation was Bay County prosecutor Edward E. Anneke.

Hotel employees had turned over the bed clothing and sheets to the police because they did not appear consistent with the story they were told. The

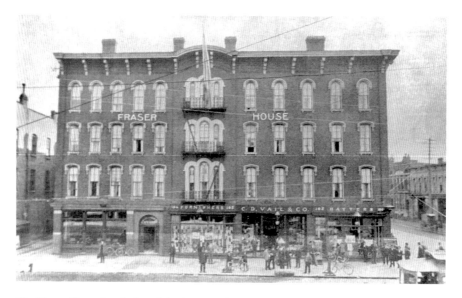

The Fraser House hotel, though in the waterfront district, was the best hotel in Bay City at the time and where "Miss Morris" died. *Bay County Historical Museum.*

investigators learned from hotel employees that the woman told them she was having an operation in her room in a week to clear up an abscess from an ear infection. Miss Morris allegedly told one female worker that she "dreaded" the operation "tomorrow" because she'd have to be chloroformed. Her words seemed to indicate that two surgeries were planned.

They said Dr. Roy W. Griswold, a young Bay City physician, had visited her on a number of occasions.

A nurse was hired and brought to the hotel supposedly after the first operation. She was identified later as Loretta McEwen, who attended Miss Morris until she died. McEwen then left the hotel and went home.

As the police began their investigation, Captain Wyman went to McEwen's house and questioned her. McEwen stated:

> *When I saw the young woman, I was very much surprised at her condition. I found her a very sick woman, whereas I had inferred that she was not very sick. I attended her through from that time out, and did everything as directed by Dr. Griswold, who had charge of the case. When he left the room Monday night, he said she could not live and told me to let him know when she died. She died at about 2 o'clock and I informed the night clerk and he told the doctor.*

The nurse also noted that Bay City businessman Edwin T. Bennett, publisher of the *Bay City Tribune* among other periodicals, had been a visitor each day. She said he did not show any affection toward the woman but noted that Miss Morris called him "Ed."

Bennett was very well known in Bay City because of his numerous ventures and business dealings, along with being a prominent newspaper publisher.

At forty-nine, he had accumulated a number of properties and owned the *Bay City Tribune* and the *Lumberman's Gazette* and had owned the *Evening Press*, retaining an interest in it when it became the *Times-Press*.

He was rather stocky, weighing about two hundred pounds, and his countenance was memorable in that he had only one eye and one arm.

He was born on April 8, 1853, in Clayton, New York, growing up near the St. Lawrence River in upper New York. During the Civil War, he was playing by the river when a marine torpedo, today known as a contact mine, exploded. The eleven-year-old lost his left arm to the shoulder and his left eye in the blast.

As an adult, he might have had a glass eye, for he wore no patch. He had a prosthetic left arm. He wore his dark hair combed straight back and sported a bushy mustache and chin whiskers.

He was a longtime member of the Knights of Pythias, serving as grand chancellor of Michigan, and was appointed as a supreme representative to the Supreme Lodge of the World. He was well known and respected not only in Bay City but also in the state of Michigan and nationally among other Pythias lodges and leadership offices.

Bennett was confronted by a reporter from the *Times-Press* after he had been called in to the office of prosecutor Anneke for questioning. He claimed that May Morris had been sent to Bay City by a friend of his and asked him to look after her here. "I paid her bill at the Fraser House, but the money was advanced by a second party."

He then referred to her character. "She has been on the turf for some time, I am informed." He said Miss Morris told him she had an abortion in Detroit, but when it came to the ear operation, she wanted it done in Bay City.

"Her parents are respectable people and they know what kind of a life she has been leading, and knew all about what caused her death. They would not let her come home until she promised to lead a better life."

Police say initial statements made to investigators by individuals being questioned in a criminal investigation are either outright lies or leave out important facts. The same was true when Dr. Griswold decided to write out a statement for the press. He claimed Miss Morris came to his office

suffering from the effects of a criminal operation, which she said had been done in Detroit, and that she had the same operation performed seven times. She said she had lived a fast life for ten years.

"She came to me a sick woman whose case necessitated immediate treatment," Griswold wrote. "It was no business of mine to publicly denounce her." He also claimed that the woman's family had known about her life and how she died and wanted it kept secret.

He said the statement she made to hotel people that she was to have an ear operation was fabricated, although she did have an earache and he had given her something to ease the discomfort.

He said the abortion in Detroit had been badly done and peritonitis had set in.

Fred Anger, a friend of the woman's family who was planning on traveling to Battle Creek on business, agreed to accompany the remains and see that they were turned over to the family. He said he did not know her, but he knew her sister and had met the rest of the family before. He said her real name was Agnes Eberstein.

Prosecutor Anneke said he had conferred with Judge Theodore F. Shepard, and both agreed that the case should be investigated thoroughly. The implication being they would be confronting both Bennett and Griswold about the facts in the case and that, up to that point, the facts did not match their statements.

A day later, Dr. Griswold and publisher Bennett were arrested by police chief Murphy at about 4:00 p.m., once warrants were authorized by police court justice Kelley.

The *Tribune* didn't hedge on the story, although it was a day late in reporting the statements by both Bennett and Griswold that had appeared already in the rival *Times-Press*. It should be noted that though at one time Bennett had bought into the ownership group of the *Times-Press*, he had no control over it at the time.

In any event, the *Tribune* reported that prosecutor Anneke ordered Dr. Charles Newkirk to travel to Battle Creek to conduct an autopsy on the woman. He said he hoped the doctor could arrive before the funeral, but if one did not, an exhumation order was also issued.

Although the autopsy hadn't been completed, the two men were arrested anyway on charges of manslaughter. There was no report on how the men were arrested, but both were arraigned immediately and released on $1,000 bond each. Perhaps this was a bit of preferential treatment given the social standing of the two men. The fact that they were charged at all, and so

swiftly, counters that claim and notes how seriously Chief Murphy and the prosecutor took what happened to Miss Eberstein.

Both the doctor and Bennett painted the young woman as a prostitute who was on the road to an early grave anyway because of numerous abortions. Up to that point, no one had a clue as to whether any of that was true.

Chief Murphy and the prosecutor traveled to Detroit to further investigate certain aspects of the case, presumably to determine the allegations against the woman and to find any connection of either suspect to her.

Meanwhile, Anneke asked that the bail be increased based on evidence found in Detroit, and Justice Kelley raised it to $5,000 each.

A preliminary hearing on the evidence was held on April 11 before Kelley. The first problem for Edwin Bennett was two of the bondsmen guaranteeing his bail withdrew their pledge, which negated Bennett's freedom prior to trial.

A hotel employee, Julia Smith, testified during the preliminary hearing that Miss Eberstein, known as Morris, had told her Bennett was her uncle as a way of explaining why every time Miss Smith went to the room, Bennett was there. She said she was barred from the room at one point, and when she finally was allowed to enter, she found the bedding spotted with blood and soiled.

Another worker, Edith Smith, testified that Miss Morris had the operation on March 23. She said Morris had told her she was to have an operation she dreaded.

The nurse, Loretta McEwen, testified she was not retained until five days after the alleged operation and arrived at the hotel on March 28. She described the woman as being very ill.

Maintaining the ruse of an ear operation, Dr. Griswold gave Nurse McEwen ear drops to administer to the woman at intervals to help with the healing. She described the situation as strange because she found no evidence that there had been an ear operation.

Bennett's arrogance was evident when the hearing was adjourned and he was to be sent to the county jail for the weekend. He and his lawyer complained that he shouldn't have to spend time in a jail like a common criminal and that he should have better accommodations. They said he should be able to stay in the city police lockup. Enough political pressure was applied to Chief Murphy that he reluctantly said Bennett could stay in the lockup until Monday.

Bennett pleaded with the judge not to be housed in the Bay County jail for the weekend because he would be treated like a criminal there. *Bay County Historical Museum.*

The hearing lasted another two days before the case was bound over to circuit court for trial. Griswold remained free on bond while Bennett this time was taken to the county jail.

Attorneys for the two defendants requested that the men be tried separately, and the court granted the motion. Jury selection for Bennett began on June 2, 1902.

It was determined through testimony that Bennett personally purchased materials, such as cheesecloth, three nightgowns and other items, that eventually were used during and after the operation.

Dr. Charles Newkirk testified that he examined the body in Battle Creek and determined that an abortion had been performed and that she had died of peritonitis. He said the operation had been recent and that a dilator had been used, indicating the woman did not perform the abortion herself. He said she had been about three months pregnant.

As the trial progressed, a large crowd of curious boys gathered, most likely to hear the lurid sexual details that were expected to be revealed. Bailiffs chased the boys from the courthouse.

Defense attorney J.E. Simonson questioned Newkirk, attempting to indicate that the woman might have naturally miscarried and that was the reason for the inflamed area and eventual infection, not an abortion.

Newkirk would not change his testimony and cited his reasons for believing why an abortion operation had taken place. He insisted that it had to have been done a few days prior to the death.

Letters written between Miss Eberstein and Bennett strongly suggested a romantic attachment, and a local minister had attempted to get Miss Eberstein to carry the pregnancy to term, saying he would adopt the child if she did so.

A woman, Rachel Randolph of Detroit, was called as a witness and testified that she operated a rooming house where Bennett and Eberstein, posing as Mr. and Mrs. Wilson, a married couple, rented a room from her for two weeks the prior August.

Bennett and Eberstein also were identified as the couple taking a room in another boardinghouse and renting a room at the Hotel Utopia in Detroit.

Once the state rested its case, Bennett's counsel team began a mission to discredit the earlier testimony. Attorney M.L. Courtright, in a statement to the jury, attempted several times to show that Miss Eberstein was "impure" and that she had "made advances towards him [Bennett]" in Battle Creek when he was there at a Knights of Pythias convention. The whole line of thought was to get the jury to believe the woman was a prostitute. Judge Shepard ordered the lawyer not to use that in his remarks.

Courtright then claimed that Bennett had asked her to meet him in Saginaw, and both took a room at the Everett House. He said he then went to Bay City to get money in order to get her back to Detroit, but when he went back to the hotel, he found she had conducted the abortion herself.

After she cleaned up, he brought her to Bay City to the Fraser House. Observers noted that during the lawyer's statement, Bennett was overwhelmed with emotion and wept into a handkerchief (or so it appeared).

Griswold was called as a defense witness at his own request and testified, as expected, that his examination of the woman showed she already had aborted the fetus at some point earlier and that it appeared the infection was very grave and could lead to death.

Another defense witness, Reverend Charles T. Patchell of First Congregational Church, said he had known Bennett for ten years and was aware of his affair with Eberstein. He testified that he first learned of the affair through Bennett's wife and talked to Bennett about it. For some unexplained reason, he had read letters Miss Eberstein had written to Bennett and his return letters to her and said he had even mailed some for Bennett. He also took some of the letters she had written to Bennett and burned them.

An unusually large crowd gathered at the courthouse when word leaked that Bennett was to testify in his own defense. He testified that he had received correspondence from Miss Eberstein that demanded money so she could take care of her "problem" or she would come to Bay City and raise a sensation and disrupt his life. He said that was when he consulted the minister for advice.

Under cross-examination by the prosecutor, Bennett admitted that he believed he was the father of the baby, but he claimed to have refused to pay her.

"I told her to go to hell," he testified about her demands for money.

He said he first met Miss Eberstein in South Bay City, or the South End, on May 5, 1901, being introduced by a mutual acquaintance. He saw her several more times in Battle Creek and in Kalamazoo a short time later. He also admitted to having lived with her in Detroit but claimed to have eventually severed his relations with her at the end of 1901 and hadn't seen her until she showed up in Bay City. He also claimed he didn't want her to have an abortion but to have the baby. He indicated he would have provided for her and the child.

In the closing arguments to the jury, it became clear that the state's case was straightforward: Bennett arranged for the abortion and Dr. Griswold performed it; however, there were complications because of infection, and he couldn't save her. It was noted that Bennett continually lied and changed stories to the point that none of it made sense.

The defense offered several other scenarios, including one in which Miss Eberstein naturally aborted and another in which she did the operation on herself.

What wasn't said was almost as important. Prior claims by Bennett included allegations that Miss Eberstein was a prostitute, had multiple abortions because of it, was extorting him and was blackmailing him for money and assistance with threats that she would ruin him.

One question not raised was how did he know the child was his if she was a prostitute? He easily could have waved off her claims, arguing there was no way to know the true identity of the father.

Another problem for the defense was failing to produce proof from Detroit or elsewhere of her being a prostitute, of ever having been arrested or of ever having had operations.

The jury was given the case at 11:00 a.m. on June 12 and retired to deliberate, but it didn't take them long. In ninety minutes, the jurors informed the court officer that they had reached a verdict. Just before

2:00 p.m., they were brought back into the courtroom, and Judge Shepard asked for their decision.

"We find the defendant guilty," the foreman stated.

Observers noted Bennett's normally ruddy complexion was ashen and that he showed little emotion when he heard the verdict. Attorney Simonson said the case would be appealed to a higher court.

Sheriff Kinney led Bennett from the courtroom and walked him across Center Avenue to the jail.

On June 23, 1902, Judge Shepard asked Bennett to stand and be sentenced. He asked if Bennett had anything to say, and Bennett declined the offer. Shepard then continued with his sentencing:

> *You are an old resident of this city, having lived here for many years. You are well known to the community and I have known you for a long time. You have been prominent in the affairs of this locality. You are a man in the strength of full manhood, a man of family.*
>
> *You have children. About one year ago you took from Battle Creek a young woman and almost two months later formed an illegal alliance with her. You provided for and kept her in Detroit in this alliance. You ended her life in Bay City.*
>
> *She was a young woman but you are a man of family in the full strength of your manhood. As a result of this unlawful alliance, she became in the family way, she came to Bay City, and submitted to the operation resulting in her death. Inside of one year from the time she met you, she was in her coffin and you before the court.*

Circuit judge Theodore F. Shepard reprimanded both Bennett and later Griswold at the end of their trials, handing down a prison sentence for each, though they were not as harsh as many expected. *Bay County Historical Museum.*

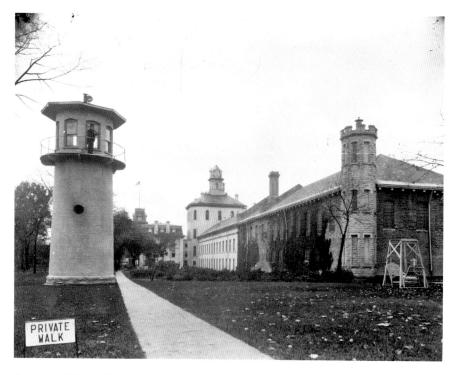

Bennett and Griswold would spend time in Jackson Prison, shown here. *Library of Congress.*

With that, he sentenced Bennett to seven years in Jackson Prison. Bennett sat down and wiped away tears.

Three days later, he boarded a train with Sheriff Kinney bound for Jackson Prison. Bennett declined to talk to reporters except to say he had no complaints of his treatment while in the county jail. While several friends had been there to see him off, his wife had not.

Part of Bennett's punishment was enduring the uncomfortable accommodations provided prison inmates, forced to live in cells only three feet wide, nine feet deep and seven feet high—only about half the size required for today's prisoners.

Two and a half years later, on Christmas Eve 1904, a train pulled into the Michigan Central Depot, and Bennett alighted on the platform. His prison sentence had been commuted from seven to four years by Governor Aaron T. Bliss, a Saginaw politician who certainly knew Bennett. Reducing the sentence allowed Bennett to be paroled at once, and he was put on a train home.

He was greeted by his brothers and a few friends but again offered no statement to the press, except that he was grateful that no one had said a

word of his predicament to his ailing ninety-year-old mother, who believed her son was on an extended business venture out of town.

As for Dr. Griswold, he did not go on trial until January 1903. Most of the same witnesses and evidence were presented in his case, plus some added testimony that he had been using cocaine. As expected, the jury found him guilty of manslaughter. Judge Shepard sentenced Griswold to only two years at the Ionia Reformatory.

And to all observers but one, that was the end of the story. That one person was police chief Nathaniel Murphy.

He was unhappy with the way the entire investigation played out and the relative rush to judgment for all concerned. He continued his investigation, traveling to Detroit to retrace his steps from the first time he had gone there on the case.

He worked the case off and on for nearly a year before finding that there was good evidence that the abortion operation had taken place in Detroit and most likely at the Hotel Utopia. In any event, Dr. Griswold seems to have been innocent, in part at least, although he still was a party to the coverup.

Chief Murphy reported his findings to the Michigan Board of Pardons, a body designed to advise the governor. Murphy also got an affidavit to be submitted by the prosecutor favoring a pardon.

The board issued findings based on Murphy's investigation that the deceased woman was of "bad character" and had had a prior abortion. It also refuted statements that Griswold was a cocaine user, finding no proof offered to back up the statements.

It was noted that Griswold had been helping at the prison as a physician's clerk, and doctors there reported no sign at all that Griswold had used drugs of any kind.

On January 14, 1904, the governor pardoned Griswold.

However, the newspapers failed to make much of the incident. It was reported in the American Medical Association monthly report.

And with that, Griswold slipped away into the fog of history.

It should be noted that the reduction in Bennett's sentence may have been partly due to what had transpired with Griswold, but it seemed clear that Bennett was orchestrating the entire situation, paying for everything and likely arranging for the abortion in Detroit. He might have thought his affair was over, but his mistress showed up in Bay City.

If a person was of a cynical nature, he or she could not rule out that, if Miss Eberstein was blackmailing Bennett, her death might have looked to be

opportune for Bennett, until the entire thread of the story unraveled. Then it was one lie on top of another to keep ahead of the investigation.

So the Bay City press mogul's reputation was gone, a young doctor's own was damaged if not destroyed and a woman was in her grave—a tragedy all around.

Chapter 8
TEN HOURS OR NO SAWDUST

Bay City was the epicenter of Michigan's lumbering industry in the mid-1880s, but the wealthy cadre of company owners wasn't about to part with profits to improve the lot of their laborers.

In fact, by the start of the 1885 milling season, the owners of the one hundred lumber mills and adjacent salt blocks lowered individual workers' pay levels by 12 to as much as 25 percent, said Thomas B. Barry, a Knights of Labor representative at the time.

As quoted in the *Evening Press* on July 7, 1885, the workers had been "unjustly dealt with." Besides lowering wages, the owners raised the price of lumber, giving their profits a double boost.

"Men do not strike for nothing," Barry added.

He was commenting in the wake of activity in Bay City on July 6 in which a number of workers at several mills refused to work, demanding that the workday be reduced from eleven to ten hours at the same pay. They hadn't just thought up the idea; the Michigan legislature had passed a bill signed by the governor setting the workday at ten hours. While some historians attribute the strike to organizers of the Knights of Labor, it appears men like Barry might have advised the strikers after it began but were not leaders of it.

The men began walking from mill to mill starting in Essexville. They talked to the workers and gave their demands to management, with the idea that if the demands were rejected, the workers would walk off the job. They proclaimed their motto: "10 Hours or No Sawdust."

It was the beginning of one of the first major strikes to hit the Saginaw Valley, leading to the closure of every sawmill from Saginaw City to the mouth of the river, meaning as many as one hundred mills and associated enterprises went silent. The discontent of workers in other industries also became evident based on their activities and reactions.

The first few hours of the action found the size of the group of strikers growing as more men failed to report to work that morning. The men were encouraged when the management of J.R. Hall's shingle mill, Folsom & Arnolds mill and Michigan Pipe Works all agreed to the ten-hour demand and stayed open.

The growing band of strikers continued moving south along the riverfront, stopping at each mill and talking to the workers. In most cases, the workers walked off the jobs and joined them. Even though a number of mill owners called police for protection and a squad of city police and sheriff's deputies arrived, the strikers were peaceful and were allowed to continue their efforts.

It was emphasized early on when the strikers met with the men from the mills that it was not an operation planned and carried out by agents of the Knights of Labor, although several of their representatives had arrived in the city.

The men knew how large a disparity there was between the wealth of the owners and the day-to-day existence of the laborers who had been toiling eleven hours a day six days a week earning between $1.50 and $1.75 a day, although skilled laborers or those on more dangerous jobs earned a bit more.

If anyone needed proof, all they had to do was take a trolley car down Center Avenue eastward to the city limits and gawk at the mansions lining each side of the road, then return home to their modest dwellings.

Along the line of march, the strikers were told much the same thing by the owners' representatives who would grant the ten-hour day only at more reduced pay. Another reason the owners didn't mind shutting down for a time was because most mills had large inventories of cut lumber on the docks ready for shipment, which meant they wouldn't lose a lot of money before the cutting season ended.

For the following two days, the strikers set out at dawn and visited a number of mills, some in operation and some already shut down to see if the owners would agree to the ten-hour day at current wages. Police greeted them in front of the Butman & Rust mill at 522 South Water Street and at the nearby Rust Bros. mill, 821 South Water Street. The men, armed with clubs, called to the workers at the first mill to shut it down and join them, which they did.

When the strikers, numbering about five hundred, moved to the second mill, more police blocked their path. This time, the crowd surged forward, threatening the officers and attempting to get inside the mill property. The police responded by pushing back into the crowd, and one officer arrested a man believed to be the leader. The strikers surrounded him and someone struck the officer in the head with a club. At that, other strikers attacked two more officers, hitting them in the head and knocking them to the ground. The officers got up, bloodied but in charge, and arrested several of the strikers.

A wagon arrived and the arrested men and two officers took them to the station for booking. The prisoners, identified as Godfrey Schultz and Jacob Franski, were charged with assault.

Meanwhile, police chief Murphy summoned all of the police and ordered them back to the mill but found the strikers had moved on to the huge McGraw mills at the head of Harrison Street farther south. As soon as the strikers came into view, the workers of the mill walked off their jobs and joined them.

Continuing south, as the growing crowd of strikers was seen coming, the mills shut down rather than have any confrontations. The police followed them, planning on making more arrests.

Another of the men who struck the police officers was recognized and arrested. He was identified as Joseph Geroski, who said he was a moulder by trade. By midafternoon, every mill not complying with the demands in Bay City was shut down. Mills across the river in West Bay City and farther south all the way to Saginaw remained in operation.

A meeting of police and city officials was held as another large crowd gathered in front of city hall on Saginaw Street, possibly aimed at causing trouble because three of their comrades were in police custody there. Mayor George Shearer announced that the charges were dropped and the men could be released, prompting a huge cheer from the crowd. Strike leaders told him they agreed their men were too aggressive in their enthusiasm to continue the strike.

The mill shutdown had its effect on other workers. For example, the stevedores, sometimes referred to as dock wollopers, went on strike in both Bay City and Saginaw, demanding a ten-cent-per-hour raise. They had been paid thirty cents an hour but said they could not live on that pay since they only were paid by the boat captains for the period of time it took to handle the cargo. The ship captains finally agreed on the increase to forty cents an hour.

About two thousand people, mainly the mill hands and some spectators filled Madison Park (now Birney Park) to hear speakers and be entertained

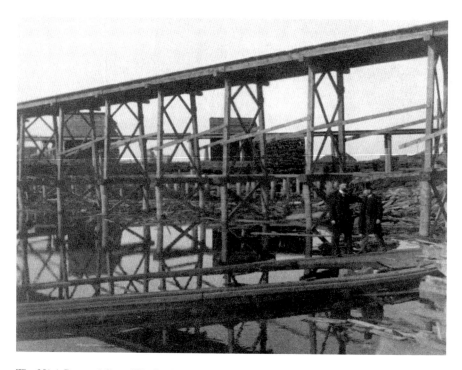

The N&A Barnard Co. mill in Saginaw City was one of the oldest and biggest mills to close down during the strike. It appears owners Newell Barnard and son Arthur are dressed for celebrations on their mill site sometime before the labor troubles began. *Public Libraries of Saginaw.*

by a brass band. One of the speakers was Barry with his Knights of Labor message. He acknowledged that most of the strikers were not members of his organization, although a few had joined.

In East Saginaw and Saginaw City, a procession of more than eight hundred mill hands and two hundred stevedores began visiting mills in those cities, and while most of the mill hands there didn't join the strikers, they simply stopped working to see what would happen. The mill owners began shutting down their operations rather than give in to the demands. Among the first mills affected were the largest ones, such as the N&A Barnard Co. mill, one of the oldest in Saginaw on the west side.

Stonecutters at the Bay City Stone Co. on Water Street walked off the job on July 13, claiming they needed an increase of twenty-five cents a day from their three-dollar daily pay. The owners readily agreed to the increase to avoid any problems and the workers returned to their jobs.

The strikers in the city even had an effect on the shoe-shine boys, who posted signs that raised their charge from a nickel to ten cents.

In another bit of bizarre circumstance, the public was shocked to hear that a band of at least twenty men had arrived from Chicago claiming to be Pinkerton detectives hired by the mill owners. (It was common knowledge that the Pinkertons often were hired as strike breakers.) They took rooms at the Brunswick Hotel at 1008 Washington Avenue.

However, a letter was received by publisher Edwin T. Bennett in Bay City from W.A. Pinkerton of Pinkerton's National Detective Agency claiming the men who came to Bay City were not from his company. He said a man using the name Matt W. Pinkerton hired the men but that Pinkerton had no relation to others of that name in the company and had no connection to the company.

Reports surfaced that at least eighty so-called Pinkertons had arrived in Saginaw, all armed with Winchester rifles ready to confront any mob of strikers intending to enter the mills. So some owners were willing to kill their workers rather than give in.

A week after the strike began, Michigan governor Russell A. Alger, forty-nine, a Civil War hero and an unabashed supporter of the mill owners since he was one of the largest timberland owners in the state, arrived in Bay City for private meetings with local mill owners. Despite a large crowd of strikers outside the Fraser House, where the talks were held, Alger refused to meet with a striker delegation.

Instead, he stepped out onto the front of the hotel and stepped up onto a table that was produced as a platform. He addressed the crowd in general terms and admonished strikers from any violence or even threat of violence. What he didn't tell them was, as he spoke, military units were on the march and would soon arrive in both Bay City and Saginaw to suppress the strike.

It was reported that Henry Sage, absentee owner of one of the biggest mills in the country in West Bay City, had arrived in town, possibly to meet with the governor. His mill eventually closed for the strike, but he refused to give in to the ten-hour demands.

In Saginaw, labor leader Barry was arrested twice, on two sets of warrants alleging he had instigated civil unrest and conspiracy. He was released on bail but mill owners were making it clear who had the power.

A number of mills in Bay City attempted to start up with makeshift crews, but when the strikers got wind of it and delegates paid visits to the mills, the owners shut down their operations. Meanwhile, the strikers gave the Knights of Labor representatives a larger role in negotiating with the owners.

Workers at both the F.W. Wheeler Co. and the Davidson Shipbuilding Co. had walked off their jobs demanding an increase in wages. Both shipbuilding

Henry Sage was one of the richest and most influential lumber barons and represented the deep divide between the mill owners and their low-paid, often exploited workers. *Bay County Historical Museum.*

firms closed down rather than hire temporary workers, but Wheeler claimed that he couldn't pay any more because of a slowdown in business. The men were being paid between $1.25 and $2.50 a day. Davidson was out of the city and did not comment on the strike.

On July 13, the rifle-toting Pinkerton agents in Saginaw stationed themselves at one of two mills planning to be restarted, and the mayor reported that three companies of state troops, along with a Gatling gun, were to be deployed in the city during the day.

Quasi-martial law was imposed by Saginaw officials with Pinkertons and other special police roaming the streets to break up any gatherings and arrest all individuals.

In Bay City, 170 soldiers from the Detroit Light Infantry, Detroit Light Guards, National Guard and Scott Guards arrived by train, stopping at Center Street, where the men marched in formation into the heart of the city. They took over the dining rooms of the Fraser House, Campbell House and Portland House hotels for breakfast before moving on to the Peninsulars' Armory at 715 Adams Street.

On July 17, two more sawmills resumed operations, agreeing to the ten-hour day at no reduction in pay, which meant a total of five sawmills and a shingle mill were operating under the agreement.

With the West Bay City mills shut down and the workers from both big shipyards also out, the Knights of Labor organized a committee to begin distributing provisions to needy families of the strikers. The provisions were stockpiled at their headquarters on the corner of Midland and Henry Streets.

Officials in both Bay City and Saginaw had contacted Governor Alger requesting the troops be removed since they weren't needed and little violence had occurred along the riverfront.

The shipyard workers' strike ended on July 25 when all hands returned to their jobs with the same hours and pay scale, although Davidson confirmed he would pay above scale once the work was resumed, and Wheeler would pay at the old rate.

By August 4, there was a report that more mills were restarting under the ten-hour system and that the business picture seemed brighter. The S.G.M. Gates mill, one of the first to be shut down, was to reopen for work when the employees met with owners and agreements were reached. An accommodation was attempted again with officers of the Sage mill. The plan had no cut in wages for those workers earning $1.50 or less, while those above $1.50 would agree to a maximum reduction of 8 percent for a ten-hour work day. The plan was rejected by Sage.

Strikers and police clashed in front of one of the Saginaw mills starting up under the old eleven-hour system, and as police charged into the crowd, several men were arrested and a few others injured by police wielding night sticks. By contrast, in Bay City, the workers at the F.E. Bradley and Co. mill, one of the earliest to accept the strikers' demands, received their first pay under the ten-hour system with full wages as before.

All was not so calm on August 12 when a large crowd gathered along Woodside Avenue after learning that men were working at the salt block of Carrier & Co. in Essexville. Word was sent out by company men to the sheriff and he, along with deputies, arrived in time to intercept the strikers. As the confrontation grew, someone fired a pistol at the officers, hitting Sheriff Brennan in the head, a glancing wound but bloody.

He gave the order for the officers to charge into the mob with pistols drawn. Several officers fired into the crowd, hitting at least one man in the arm, and the strikers stampeded to get way. Officers arrested nine men and took them to the county jail.

In defiance of the strikers, sixteen mills in Saginaw restarted operations under the old eleven-hour schedule with only two on the ten-hour system.

Local citizens were aware that the Peninsulars, Bay County's militia, were on duty at their armory and were ready to be called out if needed. Meanwhile, on August 14, separate trials were held for Alexander Beauchamp and William Sears, both accused of assaulting Sheriff Brennan during the confrontation at the Carrier mill in Essexville. Both men were sentenced by Justice of the Peace Daniel Mangan to pay fines and costs totaling $47.50 or spend three months in the Ionia Reformatory. Seven other men were awaiting a hearing on charges of rioting.

One by one, the mills in Bay City and West Bay City were opening and resuming their work. While, at one time, all of the mills were closed down, by August 24, fifteen had resumed operations, and eleven of those were under the ten-hour system, representing a bit of a victory for the strikers.

What was interesting to note was that as soon as the calendar reached September, the month when the ten-hour day became law, all of the sawmills on the river were back in operation. Some were still making the men work the eleven-hour shifts until September 19, when the law actually was to take effect and the mill owners knew they'd have to conform.

In tragic circumstances, as if to put a lid on the entire "10 Hours or No Sawdust" affair, Joseph Rabatoie, the gang sawyer at the Pitts & Cranage mill at the foot of Washington Avenue, suffered a severe injury pointing to the dangers of working in the mill. He had extended a hook onto a slab of

wood, but when it hit the saw, it pulled him forward, his head coming near the gang of blades. A grate, which descended behind the blades, caught Rabatoie's head and held it for several seconds as another hook descended, hitting him in the face. Fellow workers ran to his aid and released the grate and pulled him out before he was pulled further into the saws. They reported his face was a ghastly sight with so many cuts and gouges.

A doctor was called in and treated him at the plant and then at the injured man's home. It was reported that Rabatoie possibly would survive but with extensive damage to his face.

Another serious injury occurred on September 9 at the Miller & Lewis mill at the foot of Thirtieth Street. As millworker John Vaughn was riding a tram loaded with lumber onto a dock, it broke through, plunging him and the machine with the wood into the water, much of it falling on top of him.

He suffered severe facial injuries and a broken arm, and a second man suffered minor injuries. Vaughn was taken to his father's home on Thirty-first Street and was treated by a doctor. An investigation showed the tram equipment was rotten, causing it to break through and into the river.

While the strike was only marginally successful, the strikers proved they could shut down a large portion of the community's economic livelihood.

Chapter 9

CANADA JACK'S TWELFTH STREET GANG

Bay City had been plagued during the latter part of 1884 with a series of burglaries and robberies, and the perpetrators had managed to elude police, bringing about some criticism of the police force.

While Bay City police chief Nathaniel Murphy, the city's first full-time chief, had his suspicions, the bandits were too slippery to be identified. He had instructed his men to generate informants and to question inmates of the jail who might want to spill the beans for some leniency to get some solid leads. Tips started coming in and Murphy soon had his first real suspects.

One place in particular caught Murphy's eye, the saloon owned by John Mathieson, alias "Canada Jack," whose bar was on Twelfth Street across from Green Ridge Cemetery. Murphy believed the saloon was the "harbor" headquarters for a "desperate gang of crooks."

Murphy assigned two officers to watch the saloon from a secret vantage point in the cemetery for five nights despite the freezing-cold weather.

At 1:20 a.m. on New Year's Day 1885, the officers saw three men leave the place and proceed out the Tuscola Plank Road. A few hours later, the trio returned and entered the saloon. One of the men was holding his hands to his head. It didn't look as if they had much in the way of plunder in their possession, but the whole thing looked suspicious enough that the officers went back to the station to report it.

At 9:00 a.m. on New Year's Day, James S. Hogle, a Bay City grocer whose family owned the plank road and its four toll gates, entered the police station to report that burglars had invaded his mother's home at the second

Right: Police chief Nathaniel Murphy (front row, right), who also served as police commissioner for a time, offered innovative new views on policing in one of the roughest of lumber boom towns. *Bay County Historical Museum.*

Below: Murphy ordered officers to watch Canada Jack's place from Green Ridge Cemetery across the road. The building in the background is believed to be the same one that housed the saloon. *Tim Younkman.*

plank road toll gate, taking about sixteen dollars in cash and jewelry "after subjecting the [people inside] with all manner of indignities."

Murphy said he believed he knew who committed the crimes and ordered six officers along to prepare for a raid to be led by the captain and himself. They piled into two wagons and headed for Canada Jack Mathieson's saloon. The officers approached from two directions and took up prearranged positions surrounding the building.

Murphy, along with Captain William Simmons and a patrolman, entered the building and were greeted with "Happy New Year" by Mathieson, which they ignored. Murphy ordered the patrolman to arrest a man passed out on a sofa. Then, Murphy and Simmons started up the stairs to the second floor. They heard a window open and then suddenly slam shut and then heard another open and close. When they reached the top of the stairs, a man stepped out into the hall, attempting to pull a revolver from his pocket, but Murphy already had his gun cocked and was ready to shoot. For a second the two faced each other, but then the man held up his hands and surrendered.

Murphy surmised that the man had opened the windows in an attempt to escape but saw officers below with their guns aimed at him. The police chief opened another door down the hall and found the third bandit sleeping. He was arrested without incident or pants.

All three were transported to the police station. They were identified as William "Shang" Clark, Thomas Larney and William Brennan.

Murphy said Clark was known locally as a desperate and cunning thief, and he was wanted in Syracuse, New York, where a reward was offered for his arrest. Police had heard he was in Bay City but had not been able to track him down. He was described as a large man, and when he was arrested, he was bleeding profusely from a long and deep wound on the side of his head.

Larney had been in the city for several years and was suspected of a number of crimes, but he had eluded police. Brennan was unknown to police, but it was learned quickly that he had been a member of a gang in Detroit.

News accounts reported the three men were charged with one of the "most brutal crimes ever perpetrated in the state." While that might have been an exaggeration, it was shown to be violent when the facts were revealed.

It was noted the tollgate was about three miles south of the Bay City limits (currently Cass Avenue) and was surrounded with houses.

On New Year's Eve, several of the ladies living at the tollhouse came into town to attend a Salvation Army service leaving at home Mrs. Hogle, sixty-five; Robert Farleigh, an employee at the house; and two children, a boy and a girl, possibly grandchildren of one of the ladies. Farleigh and the boy

occupied one room while Mrs. Hogle and the girl were in another room. The little girl decided to sit in a chair near the hot stove to await the return of the women. The others went to bed.

The girl fell asleep. When she woke up at about 2:00 a.m., she went in the bedroom to tell Mrs. Hogle that the others had not yet returned. While they talked, they heard a noise. They thought the ladies had arrived, so the girl ran into the front room.

She heard a noise at the window, and when she looked out, she saw three men trying to raise it. She immediately ran to notify Farleigh, who came into the room and drew the curtain, seeing the men at work. He retrieved a revolver from his room just as the men burst through the front door.

Farleigh raised the gun at the first man's head and pulled the trigger, but the gun misfired. He retreated to another room and heard a gun cock behind him. It was fired, but the bullet missed him. He continued to retreat, heading to the backdoor and out, probably with the idea of drawing the bandits out and away from the elderly woman and children.

However, he was confronted by another man with a gun aimed at him, so he turned back into the house. He got into his bedroom and put on some socks, exited through a window and ran into a large woodshed in which there was an ice house. He climbed onto the roof of the ice house and worked to unload and reload his gun.

Meanwhile, Mrs. Hogle scurried upstairs with the little girl. One of the thieves took a lamp and followed her, calling on one of the other bandits to come and help him. They trapped her in a room and grabbed her. She believed they already had found all the money in the house, about sixteen dollars in a drawer downstairs.

She protested there was no more money, but one of the men threw her to the floor and bound her hands and feet. One of the men then took the chimney off the lamp and held the flame to her flesh, demanding to be told where more money was located. She howled in pain but repeated there was no more money. They struck her and then put a gag in her mouth, leaving her there in the upstairs room while they searched the house.

They found some jewelry and then grabbed the little boy. They forced him to go upstairs and ask the woman where the money was hidden. He returned and said there was no money.

The three men decided to go after Farleigh. Clark entered the woodshed first with a lamp in one hand and a revolver in the other. After considerable searching, he spotted Farleigh on the roof of the ice house. He raised his revolver at Farleigh and told him to come down. Farleigh said he would

come down and then picked up a nail keg sitting near the roof and hurled it at Clark, who yelled for his companions.

Farleigh realized that earlier in his haste he had not cocked the revolver properly and that was why it wouldn't fire. He pulled it from his belt, aimed at the large man, cocked it and fired. The bullet hit the man in the head, and he dropped the lamp, extinguishing it, and clutched his wounded dome. The bullet had gouged a path along his ear and scalp, but the impact didn't cause him to fall down. He raised his gun in the darkness and fired three shots in Farleigh's direction, all missing him.

Then they all heard Mrs. Hogle screaming. She had succeeded in freeing herself and had run outside hoping the neighbors would hear. The screaming alarmed the burglars enough to force them to retreat, running back down the plank road toward town as Farleigh ran to a neighbor's house to get help.

The three men arrived back at Mathieson's saloon, and one of them carried something into the adjacent barn. All of this was observed by the police watching from the cemetery.

The next day, after Murphy and his men had made their arrests, the chief directed his officers to search Mathieson's barn on the property, and when they did, they found a hiding place under the floor. There, they discovered stolen items from Mrs. Hogle and a complete set of burglary tools and other evidence of a long chapter of crime.

In Larney's trunk were a dozen empty pocketbooks and a quantity of revolver cartridges. The pocketbooks were taken from ladies in Bay City, and officials asked that anyone missing a pocketbook should call at the police station to identify it. The tools found had been stolen from H.G. Steggall's blacksmith shop and were believed to be the ones used to break open the safe at the Bay City Beef Co. in a burglary a short time earlier on the same night the tools were stolen.

Murphy said there was sufficient evidence to charge all three men, solving one of the most important cases in the city's history at the time.

Mathieson also was arrested and was compelled to answer a charge of harboring burglars and receiving stolen property. The other three were taken before Justice Petherick to answer the charges. All three were jailed in lieu of $1,000 bond each.

Mrs. Hogle, though suffering from nervous shock, attended the hearing, accompanied by the two children and Farleigh.

On January 6, several witnesses testified against Mathieson in a hearing before Justice Petherick. Henry Birney, owner of a hack company and owner of the building Mathieson was renting for his saloon, testified to receiving rent

money from Mathieson on the morning after the robbery, and the money he received was identified by authorities as that stolen from Mrs. Hogle.

Patrolman Samuel M. Catlin testified that he was one of the officers watching Mathieson's place from the cemetery and that, on the morning of the burglary, a man went into the barn. Mathieson acted as a lookout standing in front of his place. He testified that because of a full moon, he was able to see the men when they left the house to go up the plank road and could identify them as the men now under arrest. When the three returned, he noticed that Clark had a white cloth wrapped around his head. Mathieson's bail was increased to $1,500.

On January 14, Chief Murphy and Dr. Newkirk called at the county jail after receiving complaints of pain from inmate Thomas Larney. He was stripped down, and the doctor found a scar in the small of his back, one made by a spent bullet. Murphy surmised, based on the evidence, that Larney was struck by the bullet that grazed Shang Clark's head in the woodshed on the gatehouse property.

Murphy also had Larney's trunk brought to the police station and searched. There were items of men and women's clothing inside, all believed stolen.

The three criminals—Larney, Clark and Brennan—were brought from the jail at 9:00 a.m. on January 20 to stand trial in Bay County Circuit Court for a variety of felonies. After the charges were read, to the surprise of many, all three entered guilty pleas. It may have been that even though they were career criminals, they might have hoped the court would show mercy and give them less than the maximum prison sentence. It also could be they would testify against Canada Jack Mathieson as the ringleader and mastermind behind the gang. They were returned to jail to await sentencing.

The next day, the court was convened and circuit judge Sanford M. Green called for the three convicted felons to be brought before him to receive their sentences. Clark, Brennan and Larney were brought in, handcuffed to sheriff's deputies and seated at a table in front of the bench.

When asked by Judge Green if they had anything to say, Clark stepped forward and stated that he was forty-seven years old and in feeble health. He asked that the court impose on him a sentence that he would be able to survive and vowed that, when he left prison, he would lead a better life.

Larney also stood. He claimed that he was a young man and that the crime was his first offense. He asked for a light sentence and said that he, too, would be a better man in the future.

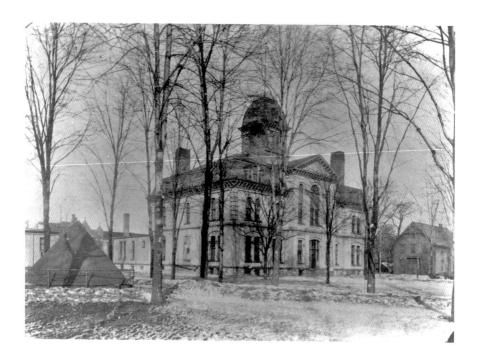

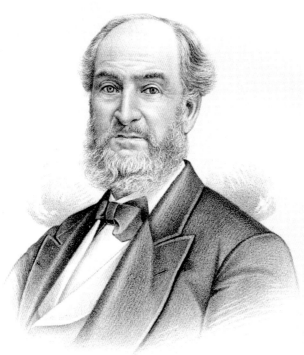

Above: The original Bay County Courthouse was the scene of many important cases, including that of the Twelfth Street Gang, whose members pleaded guilty in the hope of mercy. *Bay County Historical Museum.*

Left: Circuit judge Sanford M. Green took no pity on the violent Twelfth Street gang of bandits and ordered them to serve twenty years in prison. *Bay County Historical Museum.*

Brennan stood rigidly in front of the judge but offered nothing and shook his head when the judge asked him again if he wanted to say something. Then Judge Green spoke.

"I had an interview with the members of the Hogle family and feel confident that the charge which should have been preferred against you three was assault with intent to murder."

Green briefly reviewed the crime and remarked on the fear inflicted upon the members of the household by the men. He pointed out that it was the swift action of the law and the assurance that justice would be done prevented the outraged citizenry of seeking vengeance against the trio.

At that point, he said it was the judgment of the court that each of the three men serve twenty years at hard labor in Jackson Prison. The crowded courtroom erupted with applause and the stamping of feet when the sentence was imposed. The three of them were handcuffed again to the deputies and marched out of the courtroom.

The prisoners were to be taken by train to Jackson within the following twenty-four hours.

On March 20, Mathieson stood trial in Bay County Circuit Court.

Lizzie Stark, a native Canadian, was the first witness against him. She testified that she worked for Mathieson both when he kept the Montreal House (a notorious sporting house), which was on the corner of Sixth and Water Streets, and at the other house on Twelfth Street. She said she saw the three burglars at the Twelfth Street place and that Clark went by the alias of Brown and spent much of his time in the barroom. She said when people entered, he would retreat upstairs to a sitting room.

Henry Birney, owner of the building Mathieson's saloon occupied, testified Mathieson came to him at about 10:00 a.m. on January 1 to pay his rent.

"He paid me some money and said he would pay me some more on Saturday night," Birney said.

He noted there were three one-dollar bills, one two-dollar bill and one ten-dollar gold piece from 1881. He was shown the money in evidence, and he identified it as the money he was paid. He identified it because he put a mark on the gold coin and tore the two-dollar bill.

Patrolman Joseph Thompson said he was assigned to watch Mathieson's place and saw three men come out and go to the barn while Mathieson came out to stand watch in front. The three men then hustled down the plank road. They left at about 1:30 a.m. and returned at about 4:30 a.m. When they came back, they knocked, and someone let them in.

Patrolman Henry Houck testified that he entered the house with the chief and captain and said Larney was in the barroom, a pistol at his feet. He arrested Larney at that time.

Chief Murphy testified that he had known Mathieson about seven years and described the events leading up to the arrests.

He also noted he had been looking for Clark as early as mid-October and had gone to Mathieson's place on Water Street, where, information had it, Clark was hiding. Mathieson denied that Clark was still in town and that he had gone to Toronto.

Mathieson's wife testified that they had occupied the Twelfth Street hotel-bar about three weeks prior to January 1. She said they did not use the barn and that Clark did not stay at the hotel.

The circuit court jury returned with a verdict at 1:40 p.m. on March 21. They found him guilty of receiving stolen property knowing it had been stolen, and he was taken away to the jail.

On March 23, Mathieson was brought before Judge Green for sentencing and was asked if he had anything to say. He said he had left all to his attorneys to handle his case and that they were so confident in an acquittal that not all of the witnesses were called, including himself. He said Clark, Brennan and Larney should have been called.

He said he had only been arrested twice counting this time and that the first was for assault and battery. He asked for leniency. Green responded: "I have made inquires in the case and learned that you have lived in the city about eight years and during that time have been connected with saloons and other disreputable places harboring the worst class of men and women. I learned that you went to Detroit about a year ago and made arrangements with thieves to come to Bay City and ply their nefarious work. Your entire family has had an unsavory reputation."

Mathieson protested that wasn't true, but the judge ignored him, responding, "I have been shown a letter received by Chief Murphy from a detective giving you a bad reputation."

Green reviewed the details of the tollhouse attack and pointed out that Mathieson knew of the perpetration of the crime shortly after it occurred. He said he was informed by Mathieson's mother and by Dr. Newkirk that Mathieson was suffering with heart disease and inflammatory rheumatism. He noted that it was his understanding that Mathieson had suffered eleven attacks from his disease.

Green then said that he would make the sentence lighter in light of Mathieson's health than one he normally would have imposed.

He then pronounced that it was the judgment of the court that Mathieson serve three years in Jackson Prison.

Mathieson thanked Green for his leniency, and the end of the Twelfth Street Gang restored the public confidence in Chief Murphy, who served the department for twenty more years.

Bibliography

Arndt, Leslie E. *The Bay County Story: From Footpaths to Freeways*. Bay City, MI: Huron News Service, 1982.
Bay City Daily Times, various issues, 1931.
(Bay City) Evening Press, various issues, 1885.
Bay City Journal, various issues, 1865.
Bay City Times-Tribune, various issues, 1902–21.
Bay City Tribune, various issues, 1885–1904.
Bloomfield, Ron. *Legendary Locals of Bay City*. Charleston, SC: Arcadia Publishing, 2012.
———. *Lost Bay City*. Charleston, SC: Arcadia Publishing, 2015.
Butterfield, George E. *Bay County Past and Present*. Bay City, MI: Board of Education, 1957.
History of Bay County. Chicago: H.R. Page & Co., 1883.
Kilar, Jeremy W. *Saginaw's Changeable Past: An Illustrated History*. St. Louis, MO: G. Bradley Publishing Inc., 1994.
Rogers, D. Laurence. *Paul Bunyan: How a Terrible Timber Feller Became a Legend*. Bay City, MI: Historical Press, 1993.
Polk City Directory. 1887–88, 1895, 1907.
Portrait and Biographical Record of Saginaw and Bay Counties. Chicago: Biographical Publishing Co., 1892.
St. Stanislaus Kostka Centennial Commemorative. Bay City, MI: St. Stanislaus Kostka Catholic Church, 1974.
Wolicki, Dale Patrick. *Historic Architecture of Bay City, Michigan*. Bay City, MI: Bay County Historical Society, 1998.

About the Author

An award-winning journalist for four decades, Tim Younkman has incorporated his experience and training into all facets of his works, including essays, short commentaries, short stories, novels and historical accounts.

A native of the mountains of eastern Kentucky and raised along the sandy shores of Lake Michigan, Younkman is a graduate of Michigan State University School of Journalism and has been a crime and courts reporter for the *Clinton County News*, *Muskegon Chronicle*, *Bay City Times* and mlive.com. He also is an award-winning columnist who comments on everyday life and the important issues of the times.

He has written four digital novels merging history and intriguing crime stories.

Younkman is the father of seven children and resides in Bay City, Michigan.

Visit us at
www.historypress.net
..
This title is also available as an e-book